CONTENTS

Goals and Scope . 2
A Tree of Knowledge. 4
Producing New Knowledge. 6
Systematic Questioning and Inquiry 10
Creative Activity and Scholarship. 14
Exploration and Discovery 18
Investigation and Making 22
Integration and Technique 26
Institutional Complexity. 32
A Process That Means Different Things to Different People 36
Topic Insights and Comparisons 40
Methods and Interpretation Notes 43
Questions for Understanding and Application 47

WHAT IS RESEARCH?
Insights From Faculty, Staff, and Students

GOALS AND SCOPE
DEFINING RESEARCH FOR DIVERSE PROPOSITIONS

Answering the question *"What is research?"* is an active area of social, philosophical, cultural, economic, and technical interest. Research engages the limits of human cognition, and as a result, it can be as dynamic as human culture and evolution allow. Its definitions can also be a practical matter for detailing everything from job descriptions to economic policy, as well as tenure and promotion criteria, grant programs, and even the missions of institutions themselves.

The main task of this work is not to get the right answer per se; rather, it is to unravel and make visible multiple threads of meaning in order to ask better questions, to use these new threads to support new practices, and to create new insights about the role of the arts in research universities. The work here does not seek to describe an authoritative definition for research that can encompass all creative and scholarly pursuits. Nor does this brief seek to advance a scholarly review of the subject. Instead, this work seeks to add to our understanding of how faculty, administrators, and students think about research within the institutional context of research universities.

To accomplish this, we estimate the prevalence of different topics among a corpus of interview responses using a mix of semi-structured interviewing, open-ended text analysis, machine learning, natural language processing, visualization, participatory design, and expert interpretation. Topics are communications frames and ways of talking about a subject. The contextual and cognitive landscape that they represent is a foundation upon which arguments can be made, planning can be accomplished, and new practices built. Thus, it is critical to foreground these different topics, explore the intellectual and practical diversity of different research modes, and consider the breadth of perspectives involved in the future of the arts, design, research, and teaching in research universities. -gh-

"I think that other people define research in a variety of ways, and I sort of adopt different definitions depending on what the project is. It seems to me that people who work in the sciences define it as producing verifiable or reproducible knowledge. It seems to me that people who work in the arts can interpret research to mean producing new culture or inventing new culture."

PROFESSOR
SCENIC DESIGN

KEY TAKEAWAYS

The definition of research means different things to different people. For some, definitions are pure, specific, and very distinct. For others, definitions are influenced by a mix of modes and types of research.

Acknowledging and highlighting different types of research can be a valuable activity for building shared awareness and understanding among teams and departments.

Even though people may talk about the same approach and type of research, the language and framing may be different.

A useful approach may be to ask "when" different types of research happen in a collaboration or project.

The main categories of research presented are likely to be stable, but their relative proportion and representation of different types among different groups may vary.

People's understanding of research includes the organizational structures and institutional complexity that make it possible.

"Producing New Knowledge" is one of the most prevalent ways of understanding research, but it is not uniformly distributed across disciplinary clusters. The Fine Arts, Music, and Humanities disciplinary clusters referenced this topic less frequently than the Natural Science, Social Science, and Engineering clusters.

The "Systematic Questioning and Inquiry," "Exploration and Discovery," and "Integration and Technique" topics show the least levels of difference between disciplinary clusters.

Faculty with PhDs are more likely to refer to "Systematic Questioning and Inquiry" in their definitions of research

Certain topics in definitions of research are correlated, and many people's definitions are made up of multiple ideas about research.

photo credit: a2ru.

A Tree of Knowledge

The tree diagram to the right shows the relative proportion of topics for the definition of research and their correlation structure for 457 interview responses. Topic correlations are shown by the connected branches, and the relative proportion of each topic in the entire set of responses is listed at each node or as a sum of the combinations of topics at the parent nodes. Topic names are provided at the leaves of the tree. This branching pattern provides insights into the relative mixing of topics, their weights for this sample, and the conceptual structure and cognitive landscape for communication.

There are two main branches of this tree. The top branch contains "Systematic Questioning and Inquiry" and "Producing New Knowledge." These definitions are largely consistent with many formal and institutional definitions of research, including the scientific method, as well as those used by many university Institutional Review Boards (IRBs) and federal research agencies. For example, the U.S. Office of Management and Budget (OMB) defines both basic and applied research in part as ". . . systematic study toward fuller knowledge [or to gain knowledge] or understanding. . ." (OMB, 2016, p. 2-3).

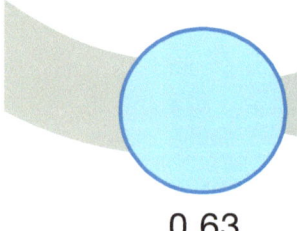

The second main branch contains a more divergent range of topics with different framings for research and associated practices. Some of these offer common senses of the definition, such as Exploration and Discovery, while others articulate and reference uses and meanings specific to the disciplines and processes involved.

The bottommost two topics on the lower branch tell us something about the domain of research as it relates to organizations of people. For "Institutional Complexity," research involves the coordination of activities within complex institutions, and partly as a result of this complexity, research is also a term that can mean different things to different people, depending on their vantage point.

Office of Management and Budget. (2016). *Preparation, submission, and execution of the budget* (Circular No. A–11, Section 84). Washington, DC: Author.

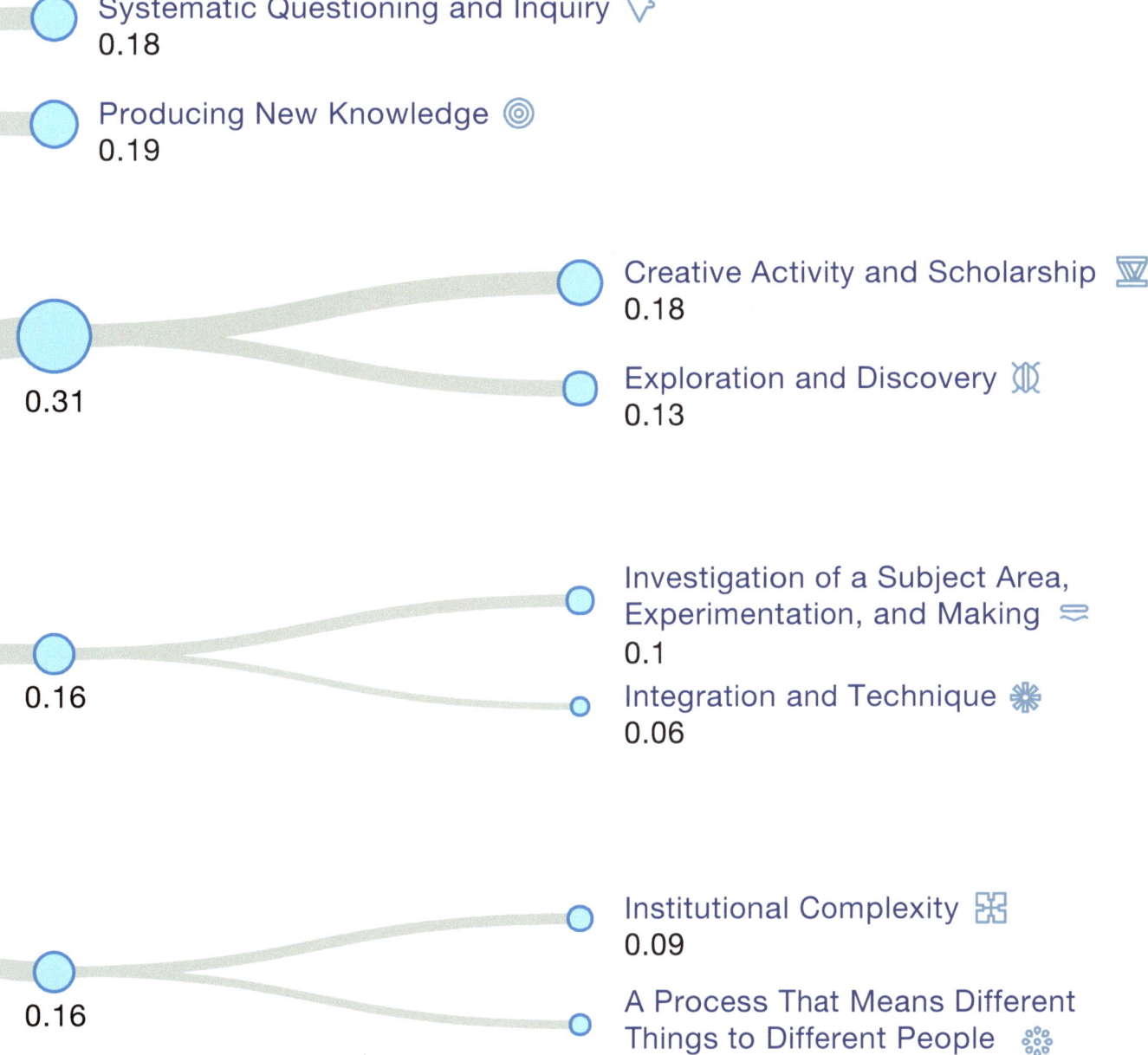

RESEARCH:
Producing New Knowledge

EXPANDING THE FIELD

> " Research in my opinion is anything that helps you continue your knowledge in either your field or how to expand your field learning other disciplines and trying to stay current and also future forward. Anything that you can learn that will help your discipline move forward."

FULL PROFESSOR
GRAPHIC DESIGN

> " I'm concerned with producing knowledge that's reproducible, that fits in different contexts. The things I care about are often things you can't hold in your hands — that you can't wrap a tape measure around. Because I care about things that you can't do that with, I have to specify things that you can put a tape measure around, the things that you can weigh. Then, I need to make an argument that those things actually represent the thing I really care about."

FULL PROFESSOR
LANDSCAPE ARCHITECTURE

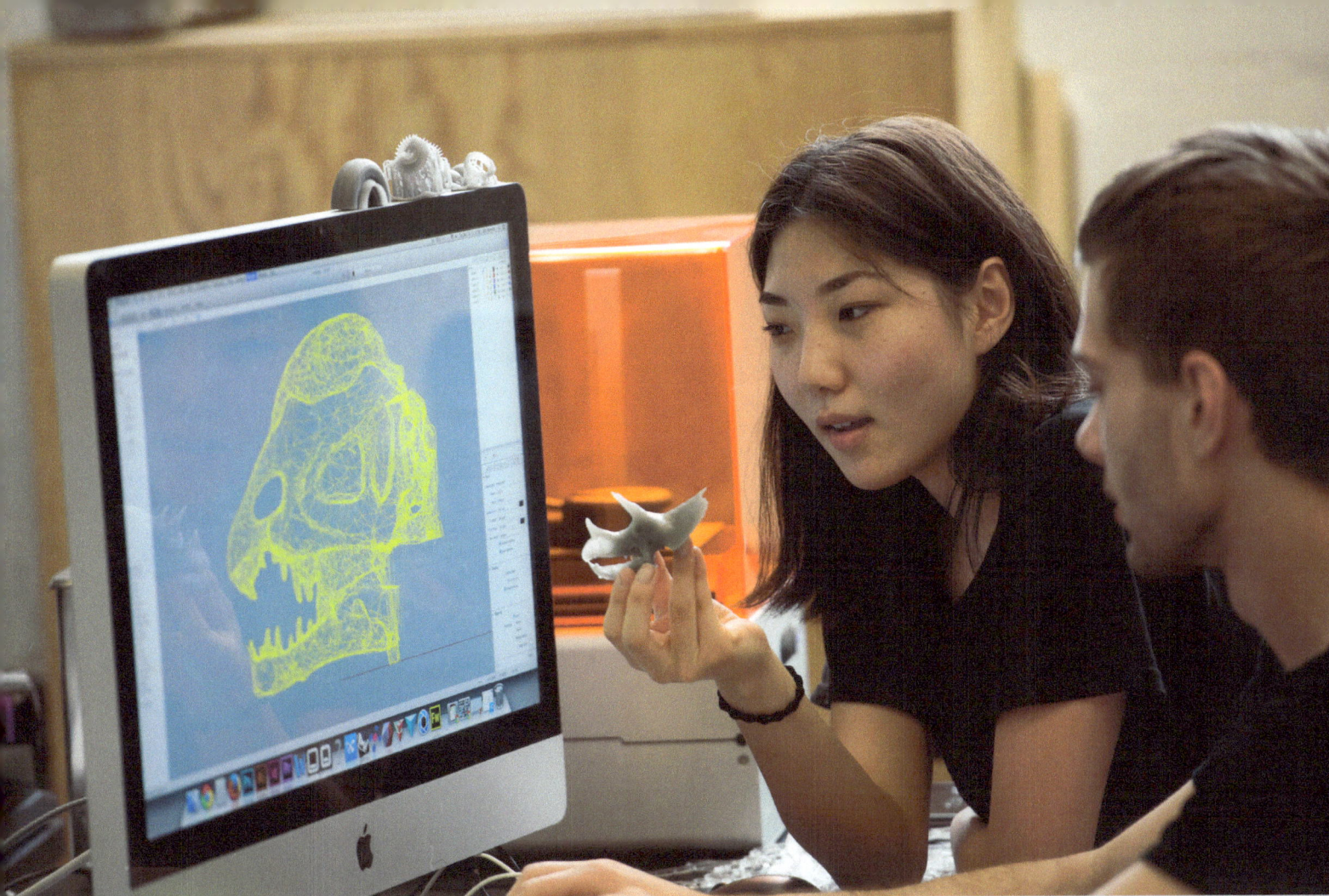

Above: Simon Remiszewski helps a student conceptualize the transition from a digital model to physical object using a 3D printer. Photo credit: Tufts University.

For a broad and diverse swath of respondents, research is the production of new knowledge. This topic is among the most widely held senses of the definition of research, and interviewees regularly described their definition as "broad," in part to help frame an inclusive definition that could encompass many disciplines, forms of scholarship, and modes of creative activity. "Pursuing," "searching for," "generating," "discovering," "creating," "expanding," and "investigating" new knowledge could all apply just as well.

"Creating new knowledge. Creating a new product. It could be a product. It could be knowledge, but creation would be the key."

"Creating new knowledge or applying knowledge in a different way than it's been applied in the past."

"I would say it's the in-depth study of the unknown to produce new knowledge, perhaps. That's kind of broad. It covers a lot of . . . I'm thinking of all the different disciplines now. You need something broad enough to cover that. Of course, we know that also applies to basic research, applied research, but in depth study of the unknown."

"Research is investigation which seeks to expand knowledge about the world. That's the kind of broadest definition I can come across. It usually establishes a fundamental question, which the research then seeks to address in some way or another. It's not just kind of rambling speculation. It's experimentation with a purpose."

"Well, research is a really broad, it's a word that can have a lot of different meanings, but generally I describe it as being the quest for new knowledge. Whether that knowledge is scientifically based, artistically based, or humanistically based, it's a quest for discovery of new ideas and new ways of thinking about old ideas."

When research is described as the "production of new knowledge," it is often coupled with other definitions, descriptions, and domain areas other than science.

"Research in the arts is probably different from research in the sciences. We don't follow the scientific method, and we don't experiment in the same way that I suppose scientists do. In our field, much of what we do that would qualify as the production of new knowledge happens in studio, in workshops if you will, where we work in small groups – professors and students. The studio is a place but also a place of study. Painters have their studios, sculptors have their studios, the architects, designers, and so on have their studios. This is where we do our research. Our research is always not unlike a scientist, I suppose. It's always associated with application. Research is applied research. We borrow things traditionally, especially in architecture. We borrow things from everywhere. When I say things, methodology, ideas, and so on and so forth and transform them into things that are relevant to the applications in our field. We do in architecture, for instance, we do research which has to do with building design, with structural design, with green design, environmentally and energy-efficient design, sustainable design, but also we research with things that have to with the history of design, aesthetics, the theory of design, and so on and so forth. It's a broad spectrum of things."

However, research as "Producing New Knowledge" is most commonly found in conjunction with "Systematic Questioning and Inquiry." Together, these two topics accounted for about one third of all definitions.

"Research is a systematic activity that seeks to generate new knowledge or new understanding. For me, research includes a host of questions or a host of concerns that differentiate what I consider research from what someone who does research to go to the library to find out which is the best window to buy for the addition on your house. I'm concerned with producing knowledge that's reproducible, that fits in different contexts. The things I care about are often things you can't hold in your hands — that you can't wrap a tape measure around. Because I care about things that you can't do that with, I have to specify things that you can put a tape measure around, the things that you can weigh. Then, I need to make an argument that those things actually represent the thing I really care about. For instance, I care about health and well-being, but you can't put health and well-being on a scale, so you have to come up with things that you say represent health and well-being, and then you have to make an argument that those things actually are representative. I care about how valid those connections are. That works on the kinds of things that I manipulate as a designer, the physical environment, things that we change and manipulate to create a healthier world, and it also relates to the other side of the equation with the outcomes that we're interested in measuring. I'm also interested in the generalizability. Sometimes, research scientists call this the external validity, the extent to which the findings are applicable to other people and other places."

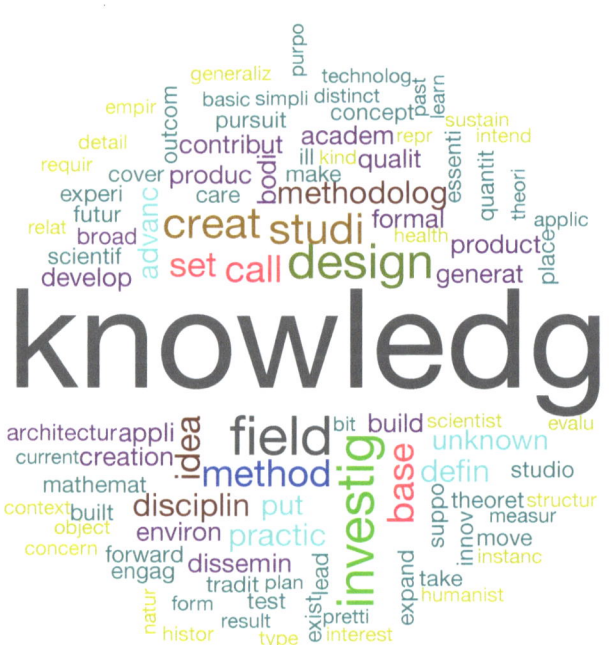

Above: *A word cloud for the topic "Producing New Knowledge" with words weighted by their probability. Larger words represent higher probability words for the topic, and color contrasts help distinguish probability levels.*

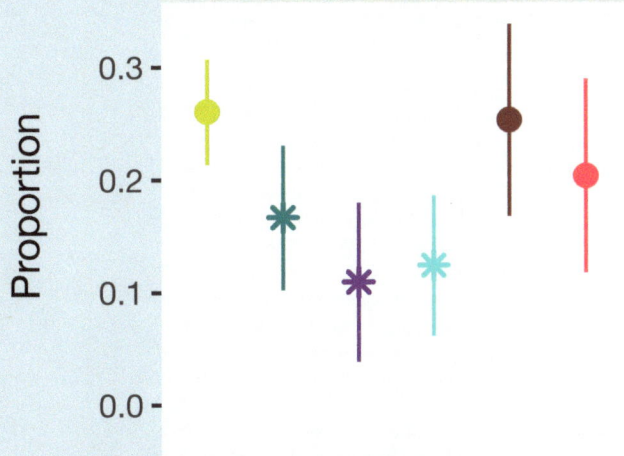

Above: Topic prevalence by discipline clusters for the topic "Producing New Knowledge." Respondents whose self-reported primary disciplines were the Engineering, Natural Sciences, and Social Sciences clusters included this topic in their definition of research in higher proportions than did respondents from other primary discipline clusters.

RESOURCES FOR LEARNING MORE ABOUT DIFFERENT TYPES OF RESEARCH AND KNOWLEDGE PRODUCTION

Bakhshi, H., & Lomas, E. (2017). *Policy briefing: Defining R&D for the creative industries.* London, England: nesta.

Biggs, M., & Karlsson, H. (Eds.). (2010). *The Routledge companion to research in the arts.* New York, NY: Routledge.

Foucault, M. (1977). *Discipline and punishment: The birth of the prison.* (A. Sheridan, Trans.). New York, NY: Vintage. (Original work published 1975)

Geertz, C. (1975). Common sense as a cultural system. *The Antioch Review*, 33(1), 5-26.

Gibbons, M., Limoges, C., Nowotny, H., Schwartzman, S., Scott, P., & Trow, M. (1994). *The new production of knowledge: The dynamics of science and research in contemporary societies.* Thousand Oaks, CA: Sage.

Gray, C., & Malins, J. (2004). *Visualizing research: A guide to the research process in art and design.* London, England: Ashgate.

Grayling, A. C. (2003). Epistemology. In N. Bunnin and E. Tsui-James (Eds.), *The Blackwell Companion to Philosophy* (pp. 37-60). Oxford, England: Blackwell.

Klein, J. T. (1990). *Interdisciplinarity: History, theory, and practice.* Detroit, MI: Wayne State University Press.

Knowles, J. G., & Cole, A. J. (Eds.). (2008). *Handbook of the arts in qualitative research: Perspectives, methodologies, examples, and issues.* Thousand Oaks, CA: Sage.

Kuhn, T. S. (1970). *The structure of scientific revolutions* (2nd ed.). Chicago, IL: University of Chicago Press.

Niedderer, K. (2007). Mapping the meaning of knowledge in design research. *Design Research Quarterly*, 2(2), 1, 5-13.

Nonaka, I., von Krogh, G., & Voelpel, S. (2006). Organizational knowledge creation theory: Evolutionary paths and future advances. *Organization Studies,* 27(8), 1179-1208.

Polanyi, M. (2015). *Personal knowledge: Towards a post-critical philosophy.* Chicago, IL: University of Chicago Press.

Swidler, A., & Arditi, J. (1994). The new sociology of knowledge. *Annual Review of Sociology,* 20(1), 305-329.

Turnbull, D. (2003). *Masons, tricksters and cartographers: Comparative studies in the sociology of scientific and indigenous knowledge.* New York, NY: Routledge.

Wuchty, S., Jones, B. F., & Uzzi, B. (2007, May 18). The increasing dominance of teams in production of knowledge. *Science,* 316, 1036-1039.

RESEARCH:
Systematic Questioning and Inquiry

SEEKING PROBLEMS, FINDING ANSWERS

> "I would define research as gaining information about a question, or a hypothesis, or a theory that you have and really snowballing it into a more defined question with a defined goal. Not necessarily a goal but a direction."

GRADUATE STUDENT
MUSIC EDUCATION

> "I think fundamentally research is activity that is aimed at answering questions, aimed at discovery, aimed at filling in gaps in our knowledge. There are a tremendous variety of methodologies that make it possible for us to fill in gaps in our knowledge. Aim for new discoveries. There are a lot of different types of activities that I would be ready to recognize as research within that kind of small compact definition of what it is."

ASSOCIATE DEAN AND FULL PROFESSOR

SOCIOLOGY

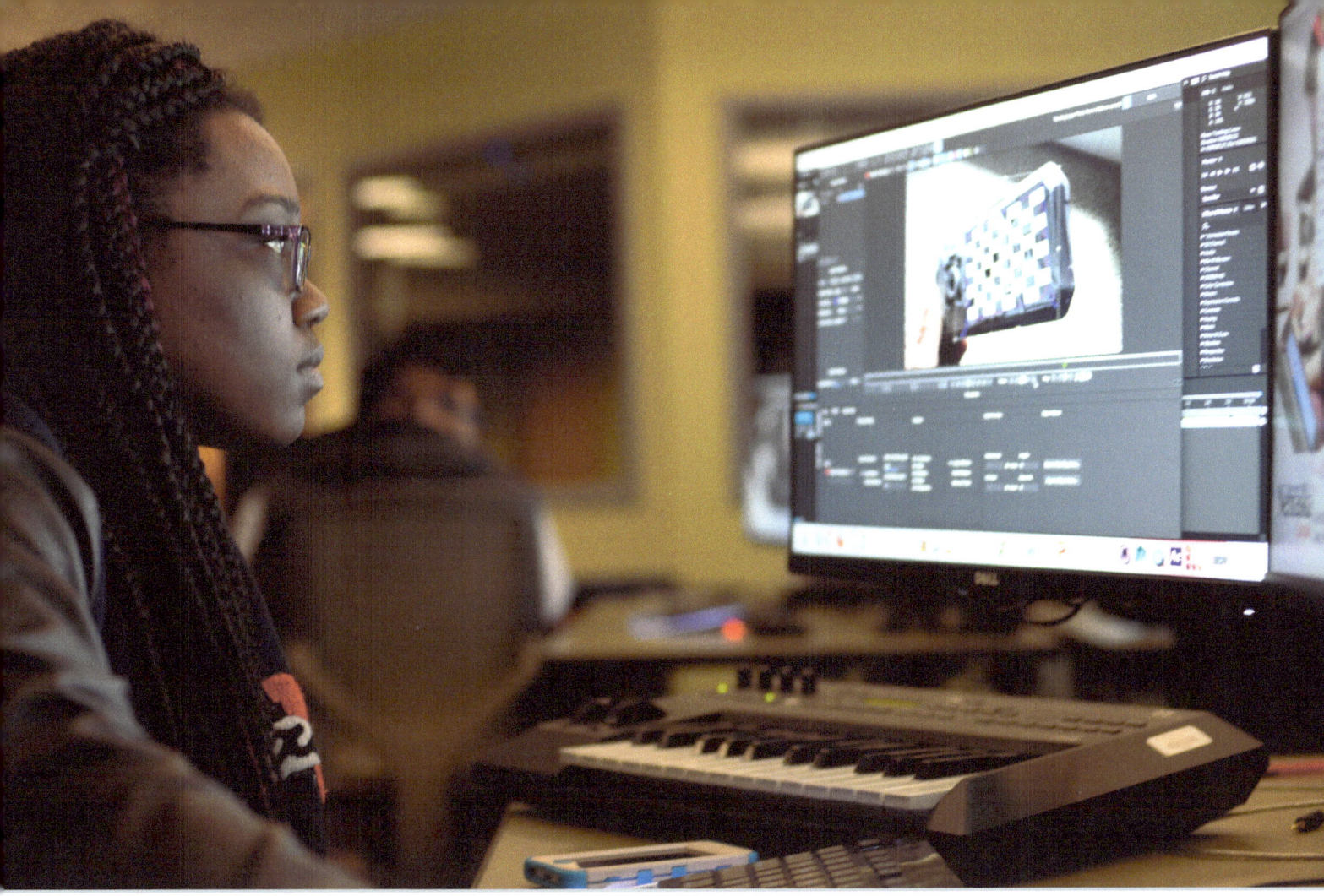

Above: The University of Nebraska–Lincoln's Hixson-Lied College of Fine and Performing Arts offers classes like Digital Media Production (above) and Foundations of Audio Recording and Production to provide interested students from all majors hands-on experience applying current technology to the arts. Photo credit: Michael Reinmiller.

Responses around this topic view research as systematic, ongoing, and informing. It involves trial and error, reframing, and a constant refinement of questions based on the answers gained through the process. And for some, their responses were unambiguous.

"I think it's defining a problem first or focusing on a problem. Then, looking into how you retrieve the answers to that problem in a systematic way."

"Research is a systematic approach toward the pursuit of truth. It has specific parameters in order to be considered research. Information gathering alone is not research. Gathering information specifically for personal interest is not considered research. Research has usually a thesis or hypothesis or question which is being pursued. And it is pursued in a systematic way, which has to be explained and described. And the parameters have to be specifically explained and described. And sources have to be properly cited in order for replication, which is one of the important keystones to research; people should be able to follow your breadcrumbs, so to speak."

"Well, it's in-depth investigation to answer a question, often. And there's some kind of rigor or a process that would be defined ahead of time. Actually, that's not even true. It's not always defined ahead of time but at least could be perhaps documented after the fact."

"I would define research as gaining information about a question or a hypothesis or a theory that you have and really snowballing it into a more defined question with a defined goal. Not necessarily a goal but a direction."

"In most research, you're asking bigger questions. Not really trying to solve anything – asking bigger questions."

"I mean, research has some classical definitions from the dictionary as sort of systematic collection and analysis of data. I consider research or the kind of research that I do tends to be small 'r' research. I think of research and development going hand in hand in all of the work that I do because all of my work has a finished goal. There's an end to it as opposed to big 'R' research, which tends to be ongoing and keep answering questions along the way. My work tends to be more project by project or research piece by research piece with an end that ends in a paper or a publication. I move on to something else or it ends in an actual product that gets released or a web application or mobile app . . . some sort of release development piece to it. I think of research as being very close to innovation and creativity where you're bringing together skills that you have and things that you don't know to answer or solve a problem or a question."

"To me, research is an endeavor where one has a question to ask. They collect data related to that question in some way, analyze that data, or present that in some kind of public audience. Now, I realize you have used the word 'data,' but that general definition also applies to the performing arts in the sense the question may be the creation of the dance or the play or whatever, and then it's that public presentation that I think is what makes research, research. We are willing to put what we have learned and what we think out for public consumption and debate and discussion."

This topic is closely related to scientific hypothesis testing, where questions are disproven and proven based on a process of systematic comparisons. But it also encompasses a broader sense of trying to understand basic mechanisms—where research seeks an objective, positivist worldview that is gained through a defined pattern of inquiry.

"I think research is the area of trying to ask interesting questions and seeking as truthful answers as we can obtain by experimentation, by data collection, by modeling, by whatever means."

Another angle on this topic was offered by a respondent who invoked Boyer's (1990) model of four modes of scholarship.

"I think fundamentally research is activity that is aimed at answering questions, aimed at discovery, aimed at filling in gaps in our knowledge. There are a tremendous variety of methodologies that make it possible for us to fill in gaps in our knowledge. Aim for new discoveries. There are a lot of different types of activities that I would be ready to recognize as research within that kind of small compact definition of what it is. I like the Boyer distinctions for research that aims at discovery and research that aims at integration and research that aims at application [see opposite page bottom for detail]. I think that there's an important place for our research that is answering not just the questions of scholars but answering questions that come from the community and from various publics. It may not be the most interesting question for scholars, but it would still be very important for researchers to engage with publics for filling in gaps."

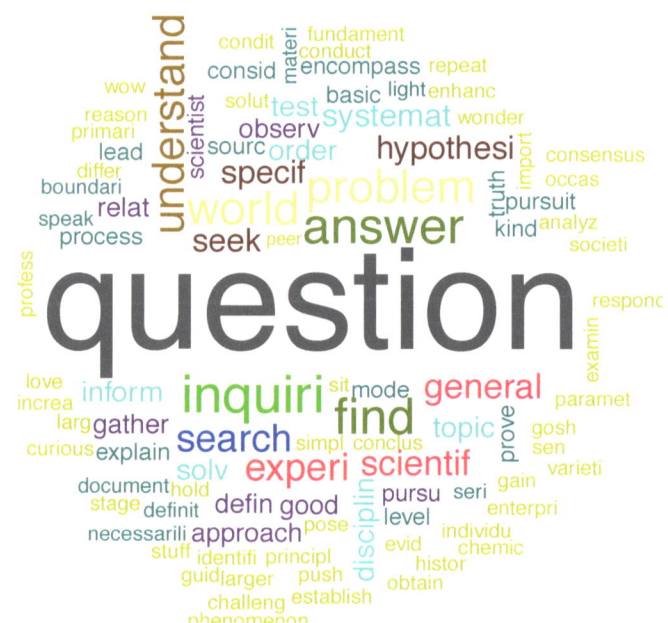

Above: *A word cloud for the topic "Systematic Questioning and Inquiry" with words weighted by their probability. Larger words represent higher probability words for the topic, and color contrasts help distinguish probability levels.*

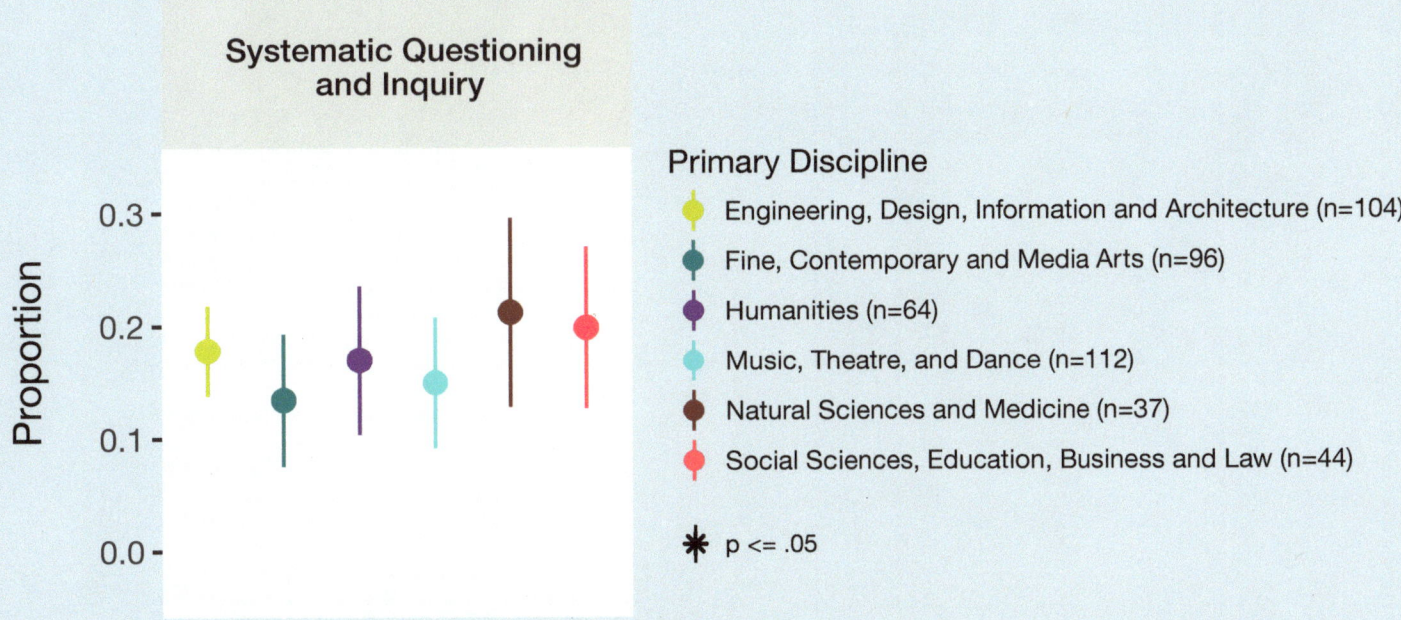

Above: *Topic prevalence by discipline clusters for the topic "Systematic Questioning and Inquiry." Although some slight differences can be observed between discipline clusters, there is substantial overlap in the proportion of respondents who cited this topic in their definition of research. This topic was the second-most prevalent among respondents after "Producing New Knowledge."*

MODES OF SCHOLARSHIP: EXPANDING THE DEFINITION

Ernest Boyer (1990) advocated for a model of academic scholarship that aimed to expand its traditional definition of research to meet new and emerging challenges. Boyer's model describes four modes of scholarship:

Discovery: This is original research that advances knowledge, and it is often thought of as the most traditional mode of academic research and scholarship.

Integration: This is synthesis of information across disciplines, topics, or time, and it includes reviews of relevant literature and comparative approaches. Today, integration may be an even more expansive mode of scholarship given the tools, data, points of view, and access that most researchers can now use.

Engagement: This is the application of expertise within and beyond the university, out in the world, engaging with different publics, and finding new pathways to advance the mission of the university.

Teaching and Learning: This is the systematic study of teaching and learning processes, including research about how to best convey knowledge, experiences, and techniques. It's pedagogy, and it's an ongoing effort to meet the needs of students and different audiences.

The gradual adoption of Boyer's model by many in academia has helped broaden awareness and acceptance of new practices and activities that advance the missions of research universities. An example for overcoming obstacles to the scholarship of engagement is highlighted in "Academic Engagement in Public and Political Discourse" (Hoffman et al., 2015). This article summarizes an examination of how academics practice their craft and how to make it "more relevant to broader publics and more responsive to pressing societal problems."

Boyer, E. L. (1990). *Scholarship reconsidered: Priorities of the professoriate.* Princeton, NJ: The Carnegie Foundation for the Advancement of Teaching.

Hoffman, A. J., Ashworth, K., Dwelle, C., Goldberg, P., Henderson, A., Merlin, L., . . . Wilson, S. (2015). *Academic engagement in public and political discourse: Proceedings of the Michigan Meeting, May 2015.* Ann Arbor, MI: Michigan Publishing, University of Michigan Library. https://quod.lib.umich.edu/m/mm/13950883.0001.001

RESEARCH:
Creative Activity and Scholarship

PRACTICE-BASED CREATIVE INQUIRY

> " It's a line of enquiry that is proposed, acted on and third-party reviewed."

DEAN AND FULL PROFESSOR
ARCHITECTURE

> " That's one of the key questions that the Arts Research Center sets out to ask. We definitely consider creative work to be a form of original research. We often use these two terms interchangeably. Arts research, obviously, is used to refer both to scholarly work on the arts as well as creative work by artists. And in our particular organization, we have a number of faculty affiliates who are not in traditional arts departments but do work on the arts, say, from the realm of public policy or public health. So we define it very broadly."

ASSOCIATE DIRECTOR
VISUAL AND INTERDISCIPLINARY CREATIVE ARTS

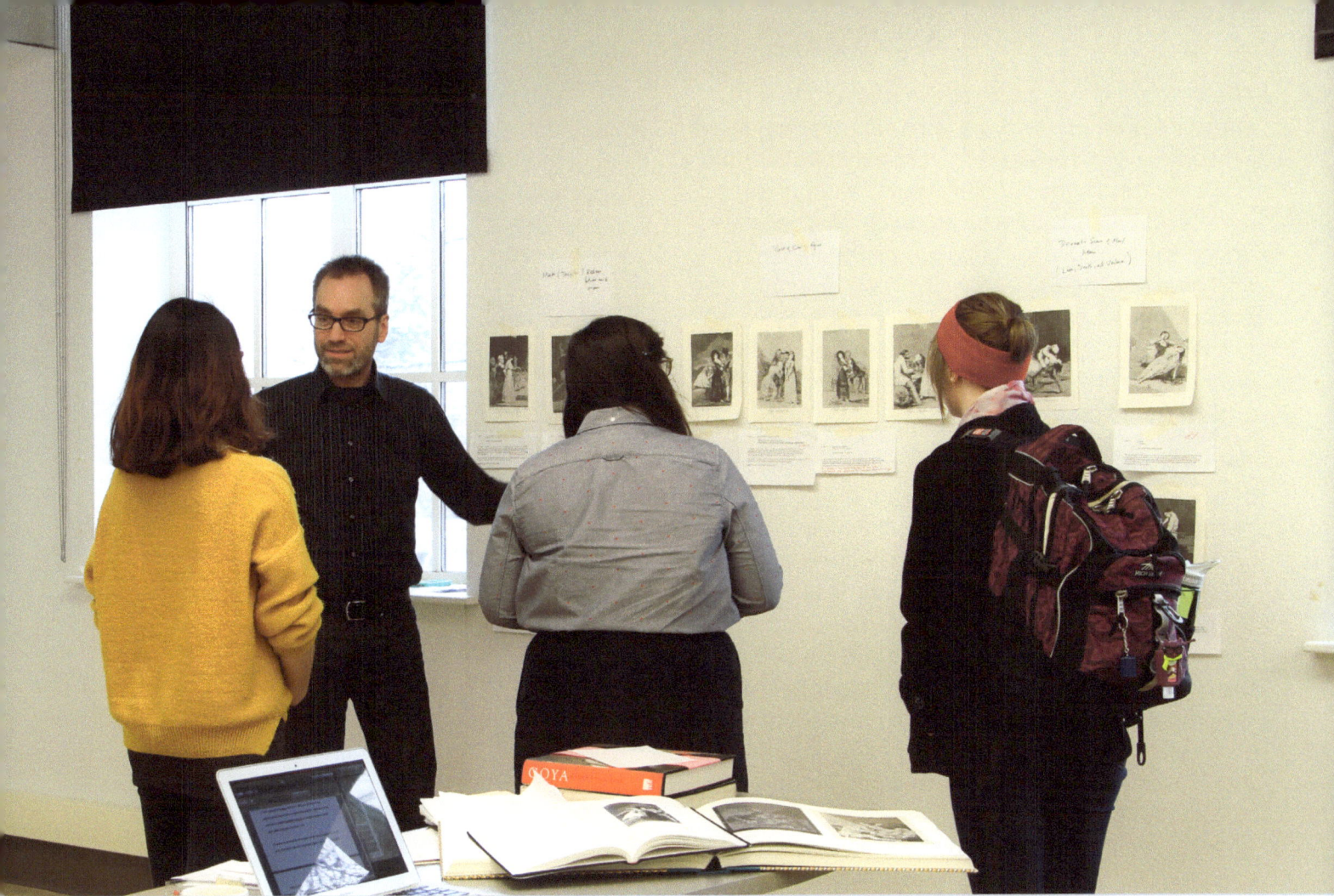

Above: Andrew Schulz, associate professor of art history and associate dean for research in the Penn State College of Arts and Architecture, speaks to students in the Borland Project Space about his research on Spanish artist Francisco Goya during spring 2015. Photo credit: Stephanie Swindle.

Research is both a scholarly and creative activity. One respondent described it as a matter of how the researchers cast themselves, and for some, the topic suggests the somewhat stipulative nature of research, where writers write and musicians perform.

"Well, for a writer, it means the daily work of trying to write poems, and in my case, also essays and translations."

"Well, for musicians, we usually think of research as performing and recording and also writing about music, which can include analytical pieces, can include CD reviews, music reviews. Our published material can be either technically published by a record label or a journal or as a book. But also, we think of performances as published material also."

Others revealed a different impetus.

"I would like to not spend the rest of my life just writing books. Books and articles are valuable and they have their place, but I think there's a lot of potential for me and others to create really fascinating new objects of study by other forms of doing that aren't just writing."

And this theme was continued by many respondents.

"I had a recent commission that involved a scholarly abstract that was accompanying the composition. This commission in particular was a little bit different from the usual commission for me. It involved an orchestration and, really, reconstruction of an existing work and therefore the scholarly aspect. I also am an expert in music copyright infringements, so I have engaged in research in that area as well. For me personally, it's very broad-based but does actually also include the creation of my art form, which is composing music. I would lend the term 'research' broadly to all of those activities, because they engage people across the university. . . ."

The outcomes can take, assemble, and even integrate multiple formats including writing, events, artworks, objects, experiments, exhibitions, policy briefs, entrepreneurial endeavors, technologies, and performances. There are even hints of genre-driven forms of research, such as the varieties of digital humanities projects, where specific constellations of techniques, technologies, practices, materials, institutionalization, audience orientation, formal elements, and motivations align and shift as noticeable types.

"In the artistic realm, there is a sort of a tension between an ongoing contemporary dialogue that's defined by the marketplace by critical discussion and a kind of personal poetic interior kind of will towards self-expression. And so some people in the arts will speak about research more asking the question: 'what does this new work have to do with the contemporary dialogue?' And the opposite pool is perhaps other folks that want to talk about self-expression. The two things are intertwined, and I think depending on the temper of the individual artist, how those things work together is a big question. I think in science there's also a contemporary dialogue of certain aspects are important at a given time. And they make up the literature in the contemporary literature. But I think underlying a lot of sciences [is] the idea that you will be able to present objective repeatable data to – if it's approved or if not approved this and some way substantiate the fact that this is objective."

Ultimately, respondents suggest that dialogue is a critical facet of the work.

"I do large community-based projects: real in-the-ground things or facilitating conversations with citizens towards some goal. It requires a lot of historical research working with historians on campus, environmental engineers, and driving a process by asking what can you do about this and engaging sometimes large numbers of both experts in other fields as well as community members to drive, facilitate a conversation to an outcome."

And the dialogue may be a place where research, creative activity, scholarship, and engagement can intersect. The Nine Mile Run Greenway Project is an example.

"From 1996 to 2000, it was called the Nine Mile Run Greenway Project. I'm trying to think how to make this a short story. By my having explored this 240-acre site right on the edge in Squirrel Hill, an affluent neighborhood in Pittsburgh where in the '20s a beautiful stream valley was purchased. . . . They began dumping slag, the by-product of steel, and basically filled this valley and ruined this stream valley. A couple environmental colleagues and myself went to a massive planning presentation in the neighborhood where they were going to put one of the last two steady lit streams in Pittsburgh in a pipe because they were going to build houses up on the slide heaps and they didn't want the smelly stream. . . . Which just perked our interest as environmentalists. Started talking to people, started doing site tours, started talking to environmental engineers and historians. Basically researched the site, the background, and then worked our way in as stewards of the greenway to help create a greenway link from Frick Park to the Monongahela River. That's the really short story, but it was a four-year project through the Studio for Creative Inquiry of actually gathering people and having discussions and driving for. . . . Short story of the outcome is it led to making a business plan, the formation of the Nine Mile Run Watershed Association, which then led to a couple years later of $8 million ecological stream restoration, the largest urban ecological stream restoration in the United States."

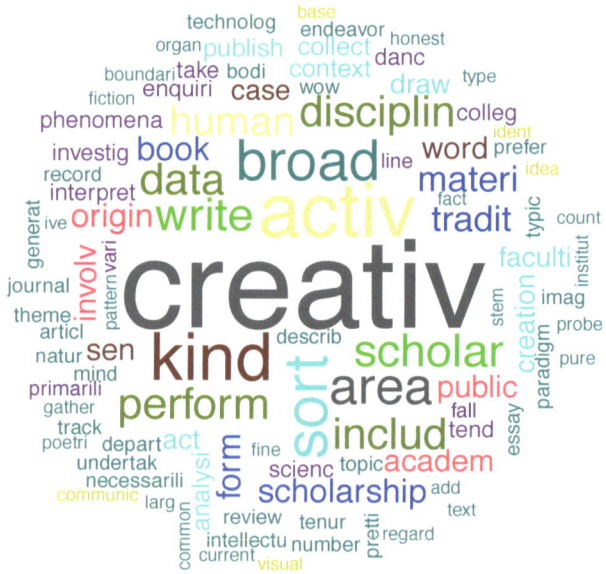

Above: *A word cloud for the topic "Creative Activity and Scholarship" with words weighted by their probability. Larger words represent higher probability words for the topic, and color contrasts help distinguish probability levels.*

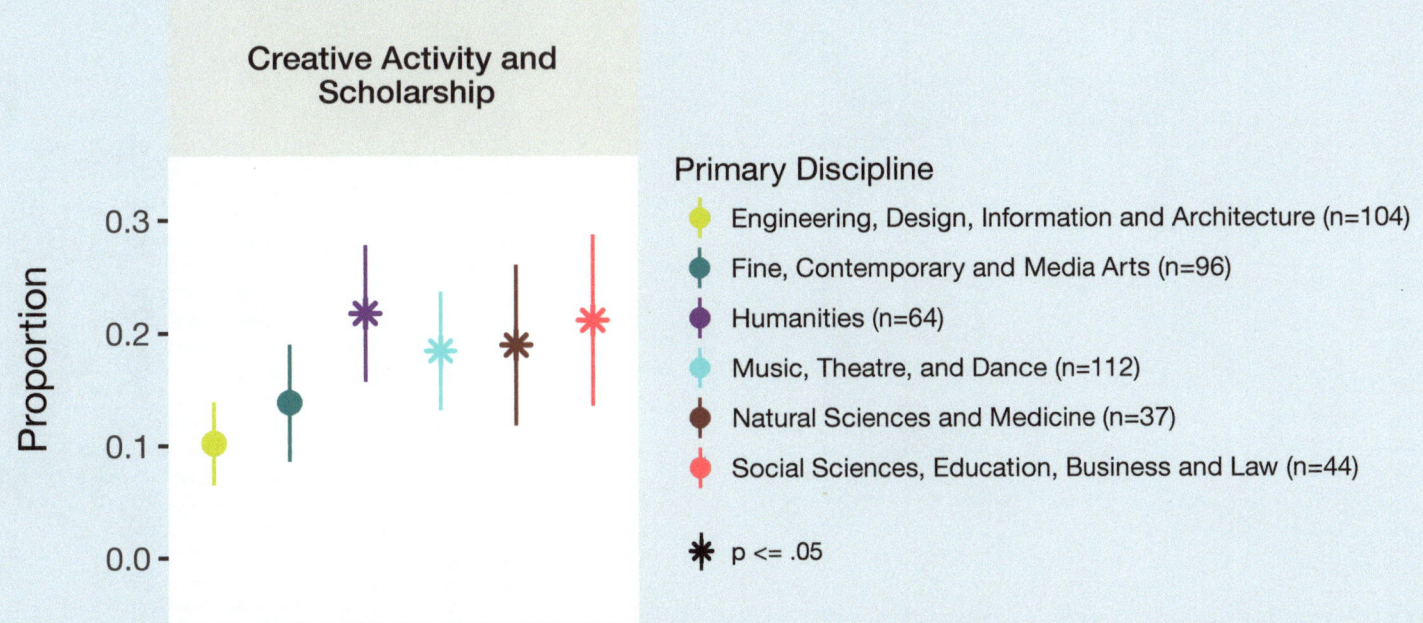

Above: Topic prevalence by discipline clusters for the topic "Creative Activity and Scholarship." Respondents whose self-reported primary disciplines included the Engineering and Arts clusters described this topic in a lower proportion compared to other discipline clusters. One interpretation of this result is the relatively higher proportion of "making" and "directed problem-solving" in the Arts and Engineering discipline clusters, respectively (see pages 35-36 of this brief for comparisons).

MODES OF SCHOLARSHIP: FROM CULTURAL TRANSMISSION TO TRUST

Recognizing and understanding different modes of scholarship is a critical task within academia, and it has profound implications for how work and labor are valued. Some of the less often discussed aspects of different modes of scholarship are how the activities of different disciplines create, codify, establish, transmit, and maintain knowledge.

A framework for understanding these issues and the implications for different modes of scholarship is described by Pascal Boyer, a cultural anthropologist whose work focuses on the cognitive science of religion and the maintenance and transmission of cultural meaning. Though primarily intended as a critique of issues specific to the field of cultural anthropology, Boyer's three modes of scholarship (2011) – science, erudition, and salient connections – work as a framework for understanding research practices because the features of each mode help describe how knowledge is formed and maintained.

These three modes help distinguish the criteria for assessing competence in a field and the key requirements for becoming a practitioner in various disciplinary cultures. For example, the sciences, the humanities, and the arts each have very different pathways for building expertise and mechanisms for assessing competence – from the training of new practitioners to the channels of communication used by disciplines to vet ideas and research.

Pascal Boyer's approach helps to explain some of the differences among research programs that exist within disciplines, and more importantly, it describes how these different modes of scholarship can overlap within disciplines to generate creative conflict and reveal new ways of knowing. Boyer's three modes of scholarship illustrate a way forward for new approaches to scholarship and research as cultural activities that are enhanced and constrained by human cognitive patterns and social practices.

Boyer, P. (2011). From studious irrelevancy to consilient knowledge: Modes of scholarship and cultural anthropology. In E. Slingerland & M. Collard (Eds.), *Creating consilience: Integrating the sciences and the humanities* (pp. 113-129). New York, NY: Oxford University Press.

RESEARCH:
Exploration and Discovery

CURIOSITY PROCESS

> " Research is formalized curiosity. It's poking and prying with a purpose."

ZORA NEALE HURSTON
AMERICAN NOVELIST, FOLKLORIST, AND ANTHROPOLOGIST

> " It's really a quest for knowledge. I believe it's basically education. I think when I conduct research I am looking to pool together related information or new information to kind of synthesize what's out there just to try have a new understanding."

FACULTY ASSOCIATE
DANCE

> " I would define it as the exploration and furtherance of exploring problems that have a global impact."

CHAIR AND ASSOCIATE DEAN
THEATRE MANAGEMENT

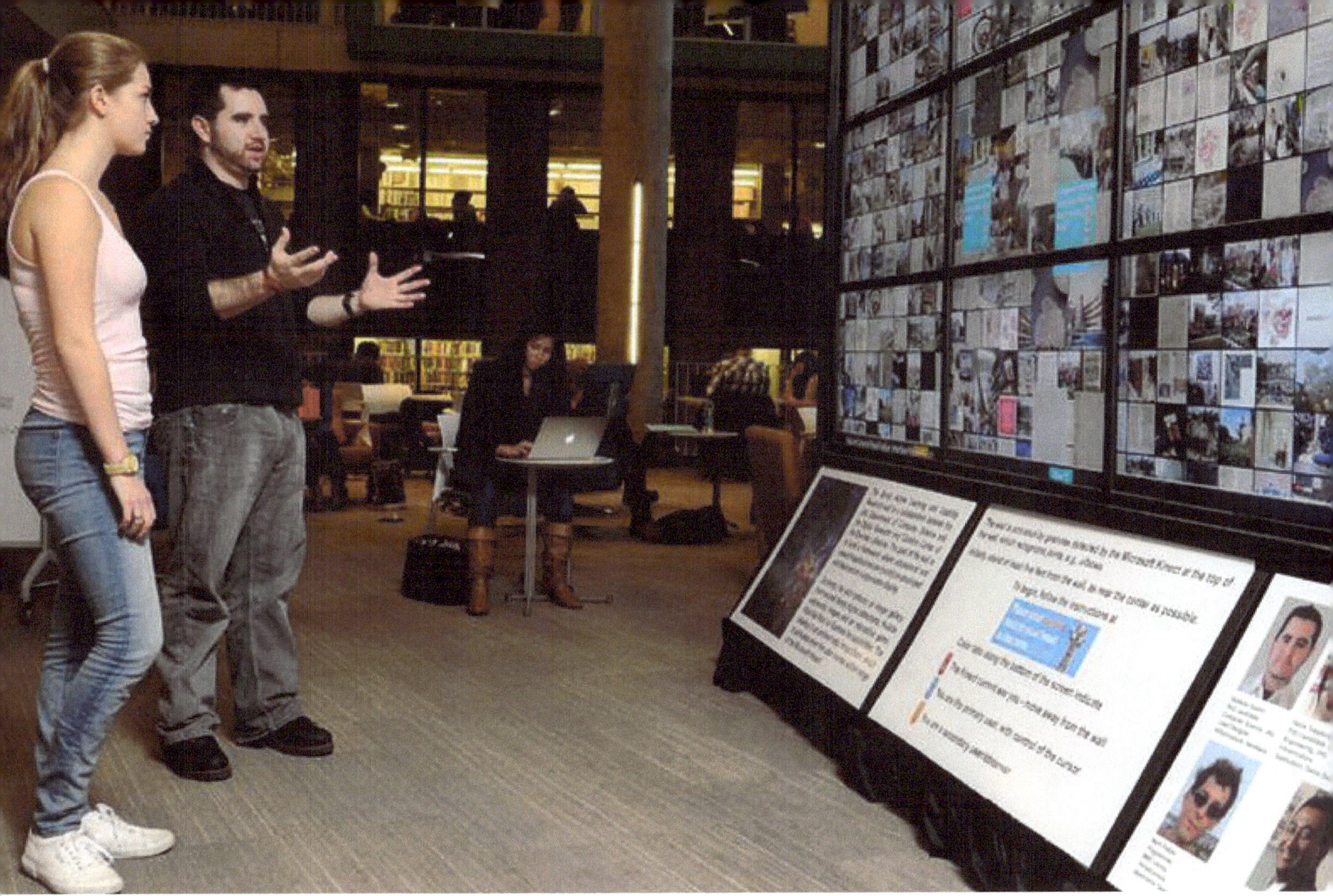

Above: The Balaur Display Wall at Johns Hopkins University's Brody Learning Commons is a collaborative project between the Whiting School of Engineering's Department of Computer Science and the Sheridan Libraries. The 84-square-foot visualization system offers insight into human-computer interaction. Courtesy of The Johns Hopkins University. Photo credit: Will Kirk/Homewood Photography.

When research takes the form of exploration and discovery, it involves curiosity about and investigation into the unknown. Exploration can mean exploring a field, ideas, a theory, new ways of working, trends, materials, or data.

"I would define very loosely the term research by any exploration of data, a. Any exploration of stuff. I think in the arts I would define research as a combination of intellectual study of the art forms that have come before the present day. Reading about them, listening to music, watching films, watching clips of theater, going to see theater, going to hear live performances. Also there's the hugely important half of it which is the practice of the arts, and in that sense I would refer to research as any kind of exploration that goes on in the rehearsal room. You might try to connect your symphony to more of what the conductor or composer is aiming for or was aiming for. In the theatre, you might try to dig more into a certain style from a certain period of history or a certain style of physical performance. I think research in the practical arts is fully corporal. It involves your soul, your emotions, your hands, your eyes, and your ears, soul. It is just anything, almost anything that's exploratory in the rehearsal process. There are of course times where you have to kind of listen to the director or listen to the conductor and follow the instructions of 'Where do I need to be or how fast do I play this note?' Maybe that's not research, but any kind of exploratory, improvisational digging into the art form, I would consider that research."

"Research is the exploration of known facts or potential collaborative opportunities to ferret out new information, to uncover things that seem perhaps oblique or opaque, and to share that in a process by which that information is more broadly disseminated, available, or inclusive."

Research as exploration and study explicitly involves observation to explore how things work, to understand phenomena, or figure out the steps or how something happens. As one respondent described, it means "figuring out the molecular and cellular steps that cause a tree to grow or an embryo to develop into an adult." *One person used an experience from childhood to say that it's* "like taking a toaster apart as a kid to see how it works." *Research as exploration and study could also mean a new way of working in an environment, developing greater skill and practice with an instrument, or developing workflows with a new technology.*

"I would define the term research really as the exploration of new phenomena, new opportunities . . . really the discovery of new approaches."

"I think about research in the arts. I think about the ways in which the arts have a mode of discovery and inquiry that is very much, I guess, to the types of research that you might think about in our lab in the sciences or in our social scientific discipline where you're really trying to find out answers; you're trying to dig deeply into problems. And you're trying to figure out new ways of approaching being in the world. And it's kind of most broadly conceived. A lot of the things that we are trying to promote in the arts are ways in which the arts can use that kind of creativity and discovery that they do so well to really forge new areas of inquiry. And so I think that's where we do see a lot of direct analogy in terms of the process and in terms of the types of activity that people are doing. We also do a lot of work at [our university] to try to connect areas that are direct areas of scientific research into arts activity."

For many, research is about satisfying intellectual curiosity, building a deeper, more comprehensive understanding of a subject, documenting what you've done, and validating it with others.

"I think research is investigation into new territories with the idea being that there will be discovery that will be shared with other people."

"I typically use it as a synonym with discovery. So for me, it's about a process through which we would make something new, even if that means from discovering something that somebody else has already known but new to a community for the first time or a new application for the first time. But there has to be an element of novelty. And again, that discovery process itself is just as important to me as a process than whatever the actual product is."

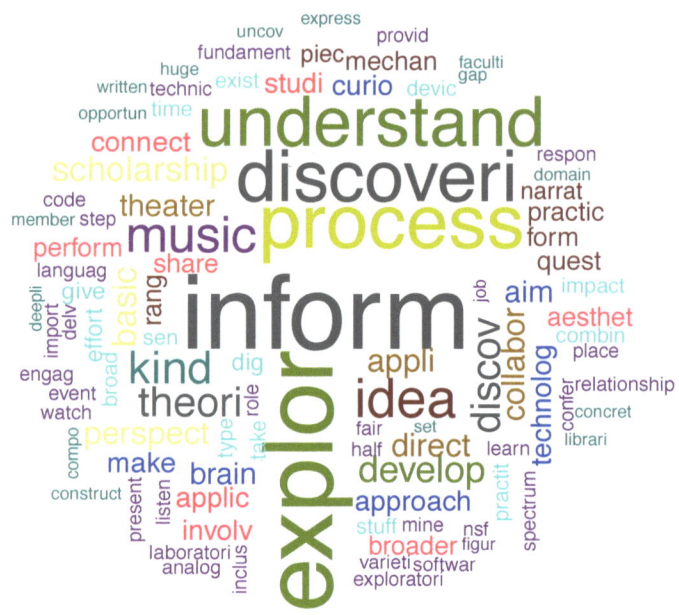

Above: *A word cloud for the topic "Exploration and Discovery" with words weighted by their probability. Larger words represent higher probability words for the topic, and color contrasts help distinguish probability levels.*

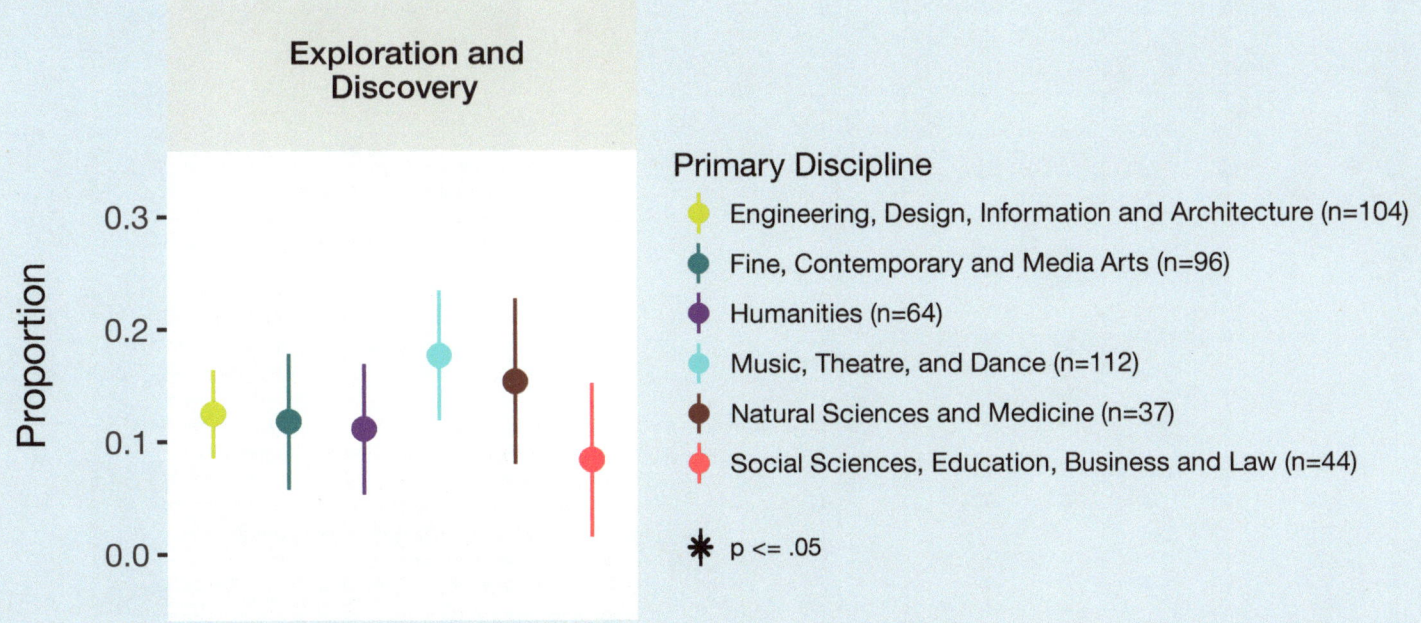

Above: Topic prevalence by discipline clusters for the topic "Exploration and Discovery." Differences between disciplinary clusters are somewhat minimal. The Music and the Natural Sciences clusters exhibit a greater attention to "Exploration and Discovery" as a communications frame for research.

Below: A comparison of the top "Exploration and Discovery" topic words for the Music and the Natural Sciences clusters. Words that had a higher prevalence among Music cluster respondents are further to the left, while words with a higher prevalence among Natural Science respondents are further to the right. Words with a more equal proportion straddle the midpoint between the two. Even though different people may be discussing similar concepts, the language and framing of those concepts can be different.

RESEARCH:
Investigation and Making

SUBJECTS AND EXPERIMENTATION

"It's about pushing myself to the boundaries of my limitations as a maker and a thinker. So if I'm working on a project I'm not only making things but I'm also reading things about it if I can or looking at things that relate to it from other disciplines or and the combination of all those activities."

PROFESSOR
DEPARTMENT OF VISUAL ART

"Research is something we spend a lot of time doing certainly at universities. I think it's a fun part of our job and probably what draws most [of] us into the field of academia. That is, it's coming up with something of interest that you're going to study, coming up with a thesis statement, if you will. Here's what I think is going on here and either running experiments whether those are physical experiments or others to gather information to better understand whatever this phenomenon is that we've decided that we're interested in studying."

EXECUTIVE VICE CHANCELLOR, PROVOST
MECHANICAL ENGINEERING

Photo credit: Northeastern University.

"Investigation and Making" included a few different senses of what research means to different practices. One is the activity of investigating a subject area, by searching through documents, archives, or other materials. There is a strong sense of the work that historians, humanists, as well as journalists undertake. Another sense of this topic is the activity of making, which also includes investigating a subject, considering the materiality of a medium, or even creating a component needed to test an idea in a laboratory. Experimentation is a common thread for the act of making, in part because so much trial and error is involved, whether it concerns developing a new performance, a painting, or a replicated experiment.

"Well, it's complicated because it's research in the making. So there's a lot of testing or trying things out that I think parallels the other disciplines, but you just don't necessarily see the results. You don't see the lab results and the field tests that they exist on the hard drive. So that's a huge part of research. For me, I guess it's a larger question. It's about pushing myself to the boundaries of my limitations as a maker and a thinker. So if I'm working on a project, I'm not only making things, but I'm also reading things about it if I can or looking at things that relate to it from other disciplines or and the combination of all those activities. It is the research and the final work and the dissemination which – because the presentation of this project at the time and a nightmare and not something I figured out and there's a problem. Because we have deadline for the first phase. So it's a combination of all those elements. It deals with some of the same testing that I think you would find in the sciences."

"Research. It's the investigation of a subject, usually within certain parameters, at least in my field. Research is what we do – 75% of what any artist does is research. It's only the other 25% that actually is the painting. Matter of fact, in your head, the painting's kind of done, or the sculpture, or the performance, or whatever it might be, by the time

you get to it, it's all background. It's already done. The actual part that the public sees is 20 to 25% of what's really there. It's a research-driven field."

"I think research is what you go out of yourself to find. As a novelist, it's interesting. I do a lot of archival research for my projects, that includes everything from work in the Library of Congress to interviews with people. As a person who's interested in pop culture, I'm really very much interested in how you document and locate things that are happening on the web and are extremely ephemeral, in new ways. So I think that research is the opposite of anything that is not interior to you that you discover through your thinking rational and creative processes. But it's going beyond yourself and then also that you're subjecting yourself to a certain degree of objectivity and rigor, recognizing that objectivity and rigor are always in some ways illusory. Because you're going through the lens of self, nothing is truly outside of self."

"For a studio artist, we tend to focus on a combination of our studio practice and how we would share our studio work with other people, particularly through exhibitions. We look to juried exhibitions, nationally, internationally, things like that."

"That is an investigation and/or an inquiry into a particular subject matter. Something that involves seeking out various sources and sometimes historical documents. Not necessarily or exclusively but something that requires one to intensively investigate a particular subject area."

"Well, I think it's an investigation of a topic, or a process, or a way of thinking, or a material, and how it can be used. I think in the arts, it's an investigation to the point where you break something and then see where it breaks. You learn the most when you break something and then you find out something valuable."

"Research is investigating a particular question or topic or, I'd like to say, a question that happens. Whether it's an artist who is doing research about a particular area of subject matter for a piece that they're making, or a scientist who's researching a particular hypothesis, I think we always have to start with a question. And for scientists, they go to the lab and do experiments and things like that.

And oftentimes, for a dancer, their lab is the studio, and they might make a dance in order to do their research. Or a composer might do research in a more conventional way, or they might sit at the piano and do research. But it still, I think, starts with a question."

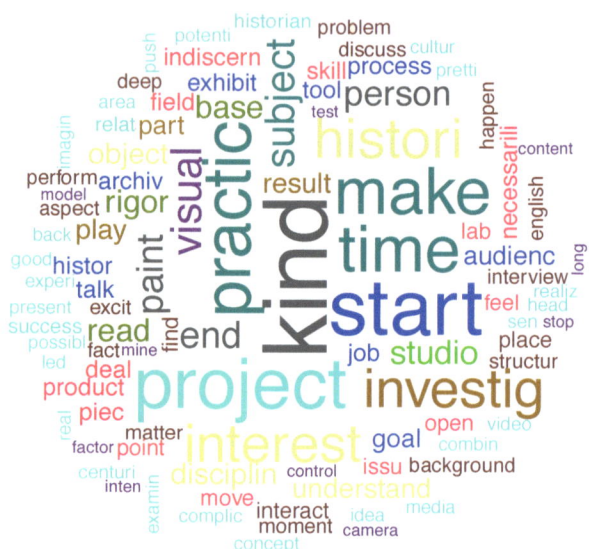

Above: *A word cloud for the topic "Investigation and Making" with words weighted by their probability. Larger words represent higher probability words for the topic, and color contrasts help distinguish probability levels.*

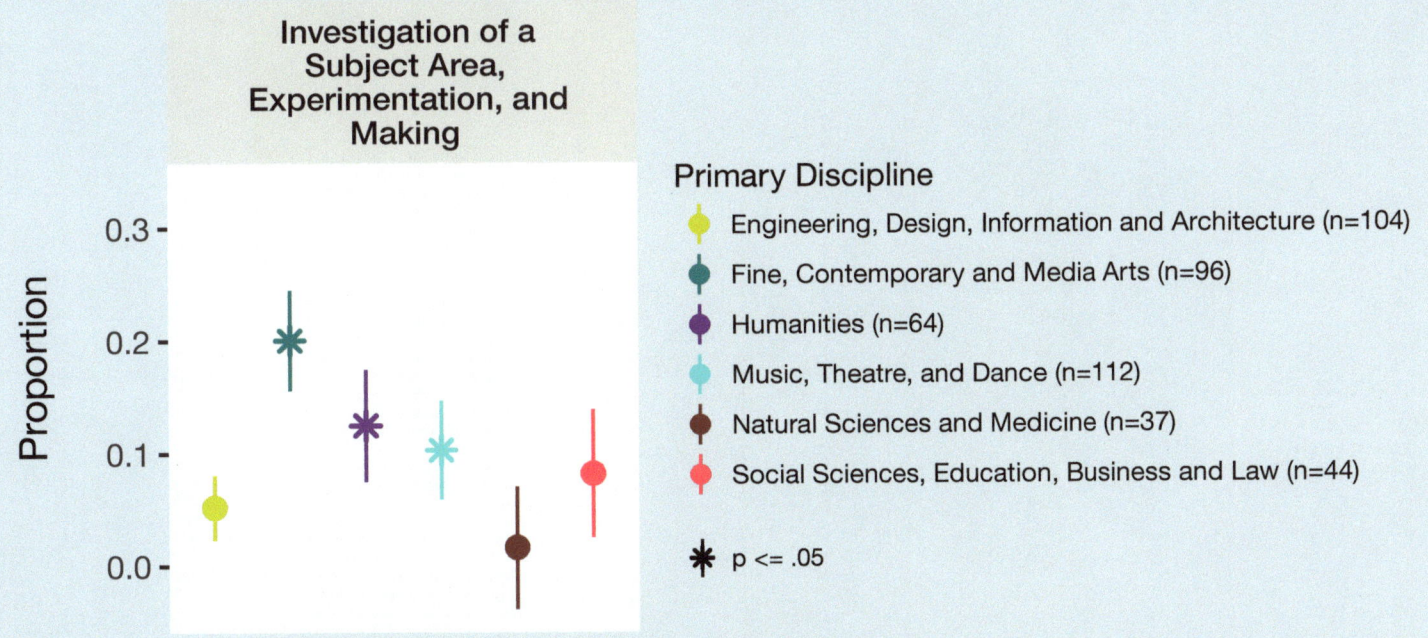

Above: Topic prevalence by discipline clusters for the topic "Investigation and Making." Respondents whose self-reported primary disciplines included the Fine Arts clusters had the highest proportion of this topic in their responses.

Below: A comparison of the top "Investigation and Making" topic words for the Fine Arts and the Humanities clusters. Words that had a higher prevalence among Fine Arts cluster respondents are further to the left, while words with a higher prevalence among Humanities respondents are further to the right. Words with a more equal proportion straddle the midpoint between the two.

RESEARCH:
Integration and Technique

INSTRUMENTAL COGNITIVE INNOVATION

> " "Research is something that is done by a performer in performance spaces. A great performer, across any art form, is always pushing envelopes and must always have mastery of fundamental components. It's not unlike a scientist who has to know all of the instruments in the lab. You must know your instrument and how to play it, well, the basics, or you certainly can't do research on the best performance of a Beethoven sonata. If it's not in tune, then it's not worth it."

ENTREPRENEUR AND VIOLINIST
MUSIC AND DIGITAL MEDIA

> " Research in the arts and humanities is work that looks into what the culture has produced down through the ages and finds ways both to make it a continuing value and impact in today's culture and also uses it as a springboard for criticism of today's culture but, most importantly, uses it as a way to nurture new creativity in our society."

DIRECTOR AND FULL PROFESSOR
ENGLISH LITERATURE

Photo credit: Northeastern University.

Research is integrating individual and group processes. It's selecting and aligning methods and methodologies. Research involves combining and contrasting ideas and synthesizing solutions. Research requires the building up of a variety of different tactics and techniques to create an approach that matches the research questions or needs of the systems involved. Research is dialogue and a dialectic. Research is integration because it needs more than one technique, and research is technique because the integration of ideas, tools, domains, and practices takes repetition, work, and expertise.

"Well, I think I define it as examining a body of understanding of knowledge and actively seeking ways to extend it or deepen it. What I think of as research in the scientific realm is different than what I think of as research in the artistic realm. In the artistic realm, there is a sort of a tension between an ongoing contemporary dialogue that's defined by the marketplace by critical discussion and a kind of personal poetic interior kind of will towards self-expression. And so some people in the arts will speak about research more asking the question, 'what does this new work have to do with the contemporary dialogue?' And the opposite pool is perhaps other folks that want to talk about self-expression. The two things are intertwined, and I think depending on the temper of the individual artist, how those things work together is a big question. I think in science there's also a contemporary dialogue of certain aspects are important at a given time. And they make up the literature in the contemporary literature."

"What's interesting about design and about architecture is that we're really living through a period where research is being very much redefined. I think it's being redefined away from a model that's dependent on let's say drawing on existing or preexisting truth or ideals or ideas, but research is about the production of usable knowledge. In architecture design, you may know, one of the most exciting developments in the last eight, ten

years, at least in terms of the way we approach our studios, has to do with the growing importance of innovation and design. Innovation, as I would like to use it, is to be distinguished from the new. If you don't mind, I'll extend on this a little bit and say that there are two things that I think are fundamental to architecture education and to design education. For me, they are very, very exciting. I think we're beginning to see these extend into lots of other curricula, including business schools and to some extent engineering, although you could say that historically some of these have already been there. Those two things are team-based work. One of the things that you see in architecture design studios is that students learn as much from each other as they do from the instructors. The instructor really is a leader. Instructors bring in briefs. They introduce context. They introduce problems. Students very often learn as much in the studio environment from each other as they do from the instructor. One of the other interesting aspects of the team-based work is that, particularly in architecture, this is true in design in general, but I think it's especially true in architecture, is that learning doesn't simply occur in teams but also is produced and disseminated in a public way. For example, if you're in English class or you're in biology class, you get the text, you get an assignment, you go home, you produce the answer, you bring it back in the form of a paper or a test you turn into the instructor. They take it home. They read it. They grade it. They give it back to you. All kind of individual, obviously, and in isolation. In studio environments, students learn from each other. They learn from the instructor, but moreover they present the work publicly as well. They literally develop the work in groups, and they present the work in groups. In architecture, the typical form of production of work and review of work is students will present, they will hang their work on a wall, and a group of critics will sit in front of them, five or six, and they will review the work. Meaning, they will critique it, they will tear it apart, they will put it back together again, as though they were clients. I think it's pretty unique to design culture; it's pretty unique to review culture in schools of architecture. Students really learn from that. It's not only answers, but they learn how to present the work. They learn how to dialogue with the client. They understand what the client may or may not be asking for. Significantly, they also learn how to re-ask the question that the client is asking. Sometimes the client is asking the wrong question, and in some ways the right question is much better than any answer that can be given. That kind of give-and-take and that kind of public learning and that kind of public presentation of the material is not unique to architecture, but it is one of the kinds of strands in the DNA. Without it, you don't have a studio culture. The other, I think, and it's connected to this idea of asking the right question, is the fundamental driver of innovation in architecture and design education, and that is prototype thinking. One of the things that students in architecture and in fact instructors in schools or architecture don't take full account of, though this is what they do, is that every exercise that is given to a student is given in a form with the expectation that the work is an answer to the question 'what if?' In a architecture design studio, the instructor may say this is the site, this is the location of the design project, these are the materials that one should use, this is the square footage, this is the budget. Those are all constraints and conditions. If those were all applied, what would you do, if then. In fact, what you see in architecture studios is . . . the work really then is based on a constant turn and spin of posing that and answering that, readjusting that

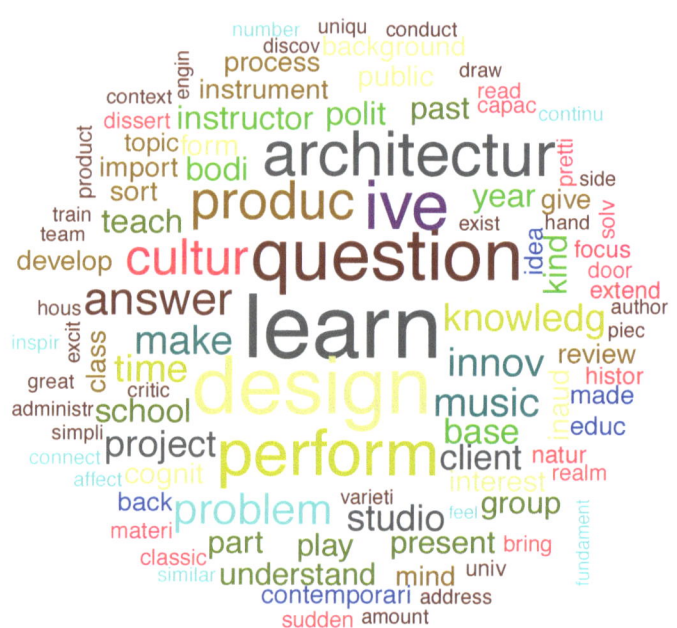

Above: A word cloud for the topic "Integration and Technique" with words weighted by their probability. Larger words represent higher probability words for the topic, and color contrasts help distinguish probability levels.

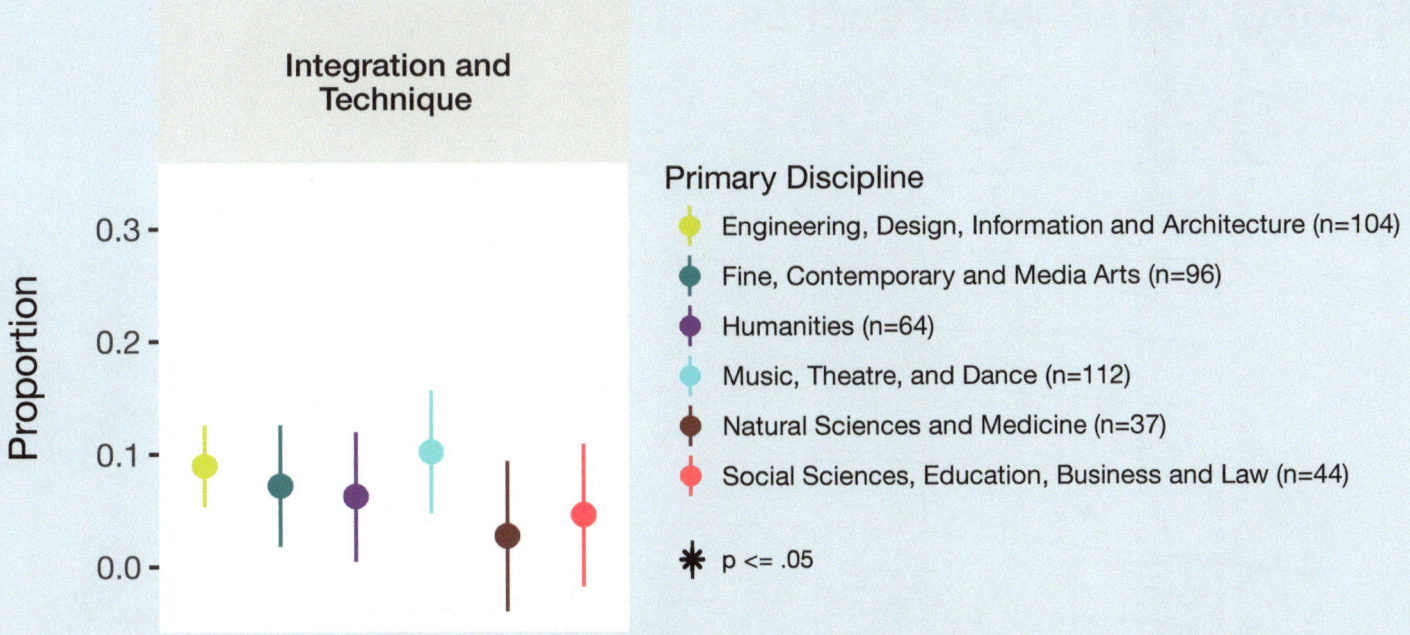

Above: Topic prevalence by discipline clusters for the topic "Integration and Technique." Although this topic had a lower prevalence among respondents, it appears to occupy an important role as a meta-perspective for integrative research, interdisciplinary technique, and the formation of expertise.

question, readjusting the answer. Students in design architecture are constantly developing prototypes to the constraints that define the question that comes with the studio project. So what if, then this. Then they get reviewed. Then the students help, through the critics and the public review, to ask a different question or to refine the question. They say, if, if, if, then this. It's a constant iterative process, which results in innovation as opposed to the new. I would say it like this: what for me distinguishes the search for innovation from the search for the new is that innovation does not exist before the problem is engaged. Let's say the new is seeking to answer a problem as given. Innovation seeks to redefine the problem in order to surface and produce things that did not occur in the problem itself."

Some respondents explicitly characterized different approaches within a discipline that are used to establish new truths (scenario proofs versus empirical research versus mathematical models, in mathematics, for example), while others compared and contrasted what the sciences and the arts value as research. But most important in these descriptions is the respondents' attention to the process of integration, as well as their emphasis on the value of technique – whether it stems from problem-solving, communicating, using an instrument, building an object, running an experiment, or calibrating a device.

For many in music, theatre, and performance disciplines, "Integration and Technique" centers on the assembly of background material, historical research, technology, and practice in order to make performances possible, accurate, and meaningful.

"Coming from the Theatre Department and drama, we look at research in not necessarily a scientific way about research, but in order to be a creative artist, you will research a play, you'll research an author, you'll do visual research. Particularly in my field with lighting, you do research to inspire you creatively, whether that goes to paintings or anything that's artistic, but on a more specific literary level, we do research time period, author, socioeconomic politics, things that are going on and use all of that information to bear on what we're creating artistically."

TRADING ZONES AND INTERACTIONAL EXPERTISE: CURRENCY FOR RESEARCH COORDINATION AND INTEGRATION

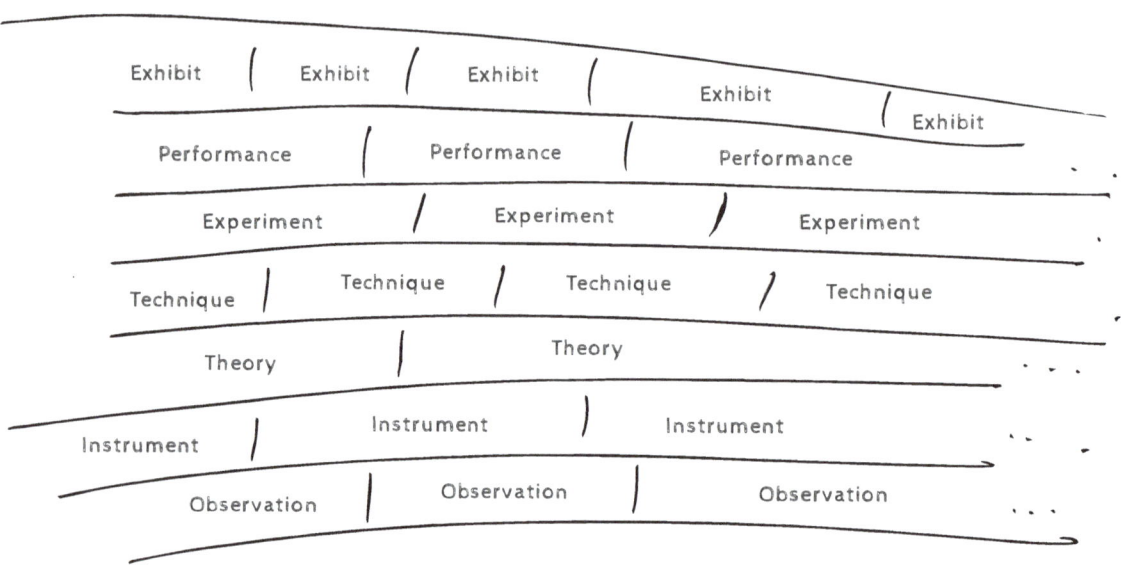

The figure above illustrates the layering of different disciplinary research activities and how they are interspersed over time (redrawn after Galison, 1997, Figure 9.5, p. 799). The implication is that interdisciplinary outcomes emerge through the interactions of theories, objects, experiences, observations, instruments, and performances at different times and with different intensities. The "trading zone" metaphor was originated by historian of science and technology Peter Galison (1997) to help demonstrate how different chronologies, modes of research, and coordination across researchers in different disciplines can nonetheless result in cooperation.

According to Galison, "Two groups can agree on rules of exchange even if they ascribe utterly different significance to the objects being exchanged; they may even disagree on the meaning of the exchange process itself. Nonetheless, the trading partners can hammer out a *local* coordination, despite vast *global* differences. In an even more sophisticated way, cultures in interaction frequently establish contact languages, systems of discourse that can vary from the most function-specific jargons, through semispecific pidgins, to full-fledged creoles rich enough to support activities as complex as poetry and metalinguistic reflection" (Galison, 1997, p. 783).

A related concept is the idea of "interactional expertise," which describes a person's ability to coordinate, contribute, and engage with other experts across different disciplines (Collins, Evans, & Gorman, 2007; Gorman, 2010). Individuals who exhibit forms of interactional expertise employ special tactics such as a focus on outcomes, agreed-upon standards, or production of an object – as well as their tacit domain knowledge, empathy, and the use of "interlanguage" to communicate and coordinate effectively. For example, journalists who work in particular subject areas are a good example of those who need to exhibit a certain level of interactional expertise in order to ask good questions and converse meaningfully with subject area experts.

These two concepts provide useful frameworks for thinking about how research – as integration and technique – emerges across distinct domains and disciplinary practices.

Collins, H., Evans, R., & Gorman, M. (2007). Trading zones and interactional expertise. *Studies in History and Philosophy of Science Part A*, 38(4), 657-666.

Galison, P. (1997). *Image and logic: A material culture of microphysics.* Chicago, IL: University of Chicago Press.

Gorman, M. E. (Ed.). (2010). *Trading zones and interactional expertise: Creating new kinds of collaboration.* Cambridge, MA: MIT Press.

RECOGNIZING INTEGRATIVE RESEARCH

In studies of integrative research, teaching, and knowledge-networking, researchers have uncovered and described a variety of practices common to those pursuits. The following four activity areas describe the kinds of practices that can lead to more interdisciplinary-driven outcomes. They are useful for articulating the qualities of integrative teaching and research, as well as for shaping the direction of incentives and methods for the future.

FIELD-CREATION AND INVENTION

Engaging in research activities in domains that sit at the intersection of, combination of, or the edges of multiple fields and/or disciplines.

Drawing analogies or extending ontologies between things that are seemingly irrelevant to one another. Identifying and prioritizing questions, puzzles, experiences, criteria, fundamentals, essential points, modes of scholarship, and pathways for success.

Creating common theory, language, or artifacts as common ground for shared understanding.

TEAM-COLLABORATION AND COORDINATION

Collaborating in teams or networks that seek to exchange and/or create tools, concepts, data, methods, or results across different fields and/or disciplines.

Coordinating and communicating such that individuals in one or both groups gain awareness of the roles, interests, and difficulties of the other(s) and, in the process, mitigate misunderstandings and confusion.

Providing inspiration, validation, and knowledge and context where necessary.

CROSS-FERTILIZATION AND ADAPTATION

Adapting and transferring tools, concepts, data, methods, traditions, practices, or results from different fields and/or disciplines that have the potential to create value or interest from one group in another group or context.

Countering intuitive expectations about how value and interest can be created.

PROBLEM-ORIENTATION AND SYNTHESIS

Engaging in topics that not only draw on multiple fields and/or disciplines but also serve multiple stakeholders and broader missions outside of academia.

Synthesizing new behaviors, practices, modes of communications, and beliefs that combine the concerns of multiple groups.

Shaping the scope of tasks and activities to work on multiple time-horizons.

Creating new holistic understanding and resolving differences between disciplines or worldviews through the development of a metaphor, framework, or other cognitive device (i.e., moving from concrete to abstract).

Applying and validating new holistic understanding to an existing problem, context, or domain (i.e., moving from abstract to concrete).

• • • • • • • • • • • • •

This list employs, builds on, and synthesizes work from the following:

Burt, R. S. (2004). Structural holes and good ideas. *American Journal of Sociology*, 110(2), 349-399.

Mansilla, V. B., Duraisingh, E. D., Wolfe, C. R., & Haynes, C. (2009). Targeted assessment rubric: An empirically grounded rubric for interdisciplinary writing. *The Journal of Higher Education*, 80(3), 334-353.

Rhoten, D., & Pfirman, S. (2007). Women in interdisciplinary science: Exploring preferences and consequences. *Research Policy*, 36(1), 56-75.

RESEARCH:
Institutional Complexity

ORGANIZATION COMPOSITION AND PERFORMANCE

> "... the full spectrum of research covers theoretical pieces to clinical experimentation to outcomes research and any inquiry which engages human creativity and inquisitiveness, hopefully, with an eye towards application of the discoveries, whatever they are, to the betterment of the human condition."

DEAN AND PROFESSOR
MEDICINE

> Essentially we have a machine running that makes research happen. It's very much driven by the faculty themselves."

DEAN AND FULL PROFESSOR
COMPUTER SCIENCE

> "... but we are really complex as an institution, so it's had to say there's one versus the other. And I think many institutions are trying very hard to figure out ways to bring these disciplines together. . . ."

VICE PRESIDENT AND CHIEF INFORMATION OFFICER
INFORMATION TECHNOLOGY

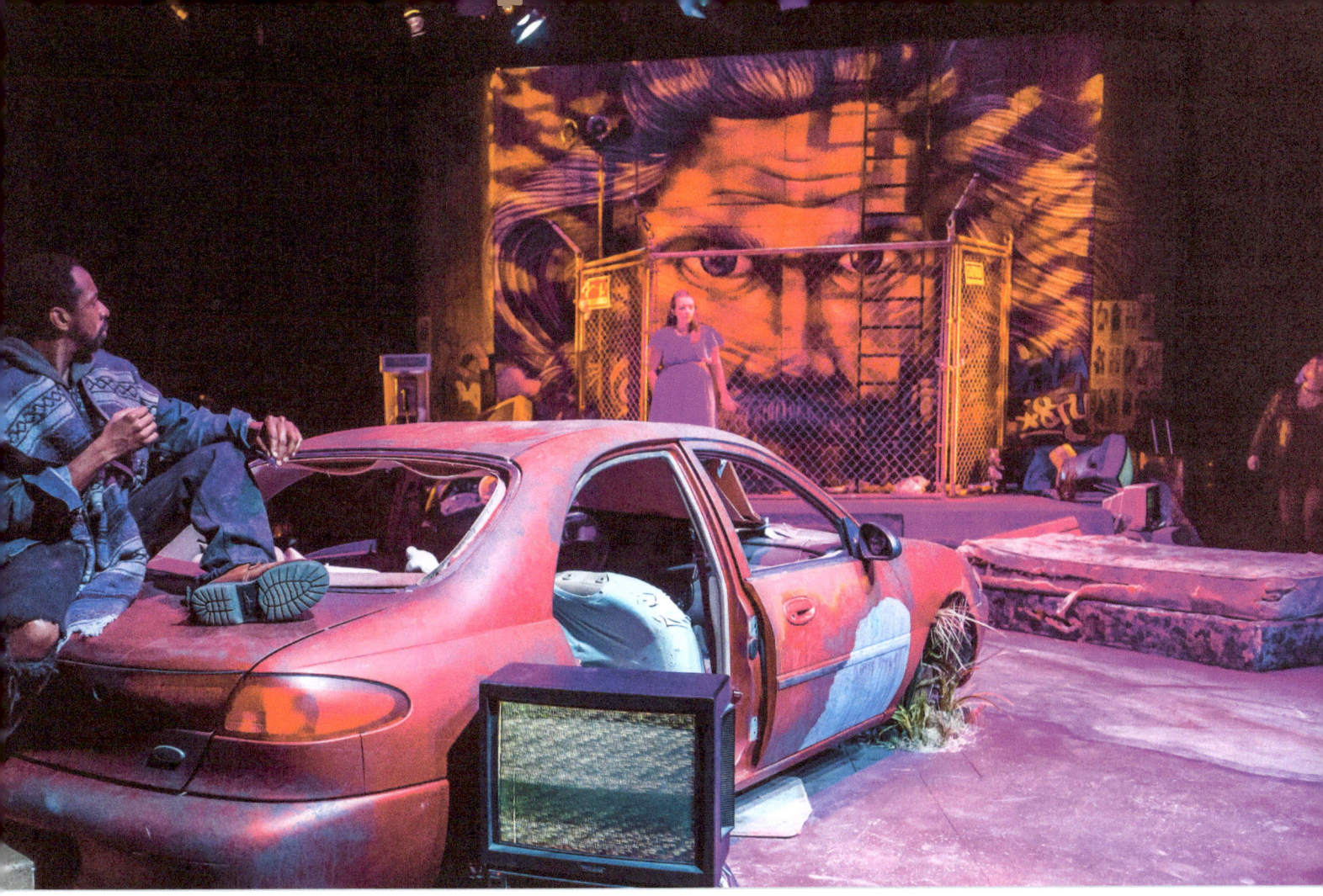

Above: Illinois Theatre at the Krannert Center for the Performing Arts. Photo credit: Darrell Hoemann.

It may seem counterintuitive to describe research as "Institutional Complexity." However, the role of the institution, diverse departments, coordination, technical and social infrastructure, and collaboration all served as an important topic and thread through many responses. This topic may belie a point of view shared by those in administrative positions, but it is a critical one for understanding what research is and how it is defined.

"I would define research in the way I think a lot of people in the university would define research, at least research scholars. Peer-reviewed articles, public sphere intellectualism, mentoring of students, creative pedagogy and approaches to data, etc., etc. Now that I work in this capacity as an administrator, I'm beginning to see how I'm still an educator, but it's more of an out-of-the-classroom pedagogy in approach. My laboratory is no longer the laboratory of where I go in and think about my own ideas. It's in a way the entire research university. For me, research has an expanded quality that also deals with what we can do for students, not just what professors can do for their own work. For example, I think of university as a laboratory not just for scientific research or research humanities and fine arts and the social sciences but also a laboratory where we tell news stories about the world and about ourselves. What I find is that students for the first time may meet other students in a way that they can never meet them in any other classes."

"Well, we are very diverse, like any complex research found in university, and so it's hard to really say there is a dominant one. I think, we have a very strong, traditional core in the arts and humanities . . . , a very rich liberal arts institution in the middle of a lot of wonderful, professional schools, each of them doing their own thing, whether it's international diplomacy for core engineering, or medicine, or veterinary medicine, for that matter. But yeah, that's core,

clearly. Our largest school is the arts and sciences, has a very deep and rich humanities core there. But we are really complex as an institution, so it's hard to say there's one versus the other. And I think many institutions are trying very hard to figure out ways to bring these disciplines together to gather some of these problems, which truly are interdisciplinary, and try to bring the sciences, and the humanities, the sciences together in ways that well help us come up with innovation. And that always challenging, but that's – there's a lot of interest and activity in the university in trying to do those things; helping us think beyond what we have gotten our graduate degrees in or what department we happen to be sitting in."

"Coming from the library side of things, we've tried very hard to answer that question just for ourselves. . . . We like to come to our work at the library with a big picture . . . , to try to promote a bigger picture in a more imaginative sense of what a library can contribute to, also the imaginative and the more wondrous aspects of research and discovery on a bigger scale."

". . . I would say that research embodies activities that generate new knowledge and in some documentable way can include all disciplines, and that new knowledge, I try and interchangeably use the word, words, because disciplines have difficulty, because I come from the STEM area – science, technology, engineering, and mathematics. My colleagues in the humanities and social sciences feel better when I use the words creativity, innovation, and descriptors like this in discussion around how research is defined. Another of the elements that is a sticking point, and for us, is that research is very often, in our world, integrated with the active participation of a faculty member. It is rarely accomplished by, in our world, the students just going out solo on their own and generating new knowledge."

"And the full spectrum of research covers theoretical pieces to clinical experimentation to outcomes research and any inquiry which engages human creativity and inquisitiveness, hopefully, with an eye towards application of the discoveries, whatever they are, to the betterment of the human condition. And I think that's very important. We do engage in fundamental research here as a major emphasis of the university, as well as the School of Medicine. But in today's world, where research is expected to deliver something that's tangible, that actually influences the quality of life, one has to always be thinking about, 'what is this knowledge good for and how can it be used to the betterment of society?' So at this institution, we have a significant emphasis on – and this is a world one – word translating the value of the science to something that has an impact on the human condition. And that could be, in the university sense, the creativity of the arts, either in performing arts or in the other media where the human condition and spirit is conveyed to what we do mostly in school."

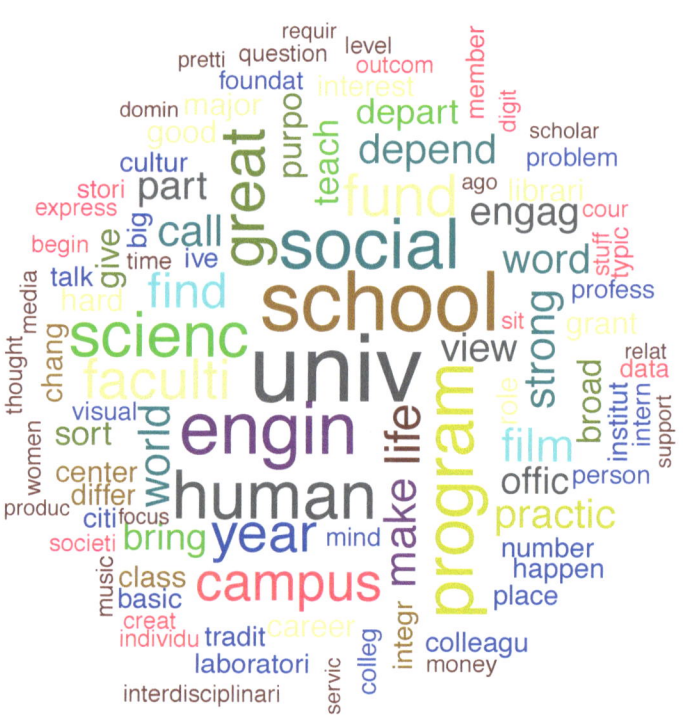

Above: *A word cloud for the topic "Institutional Complexity" with words weighted by their probability. Larger words represent higher probability words for the topic, and color contrasts help distinguish probability levels.*

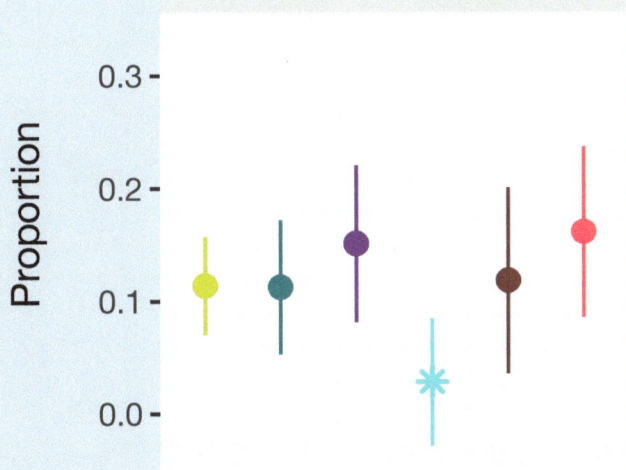

Above: Topic prevalence by discipline clusters for the topic "Institutional Complexity." Respondents often spoke about research as a characteristic of multiple disciplines, departments, roles, objectives, values, funding mechanisms, and other institutional infrastructures.

POST-NORMAL RESEARCH

The figure to the right outlines a continuum of research modes – from basic to applied, from consultancy to the "post-normal." Much has been made about the difference between "basic" and "applied" research, and it can be a useful framework for thinking about new practices across different disciplines, but critical thinking also requires that we move beyond dichotomies, especially as we consider different modes of research with an engaged society (Iyengar, 2015).

Funtowicz and Ravetz (1995) proposed such a framework as a way to approach the new risks and impacts of science and technology and to consider new ways of engaging with society, describing it as "science for the post-normal age." The figure (right) is redrawn from their model as a way to help think through the role of different forms and modes of research and how they might engage in different ways. "Post-normal research" is work that engages with extended peer groups and publics as a mode of addressing new sources of uncertainty, new use-cases, and the scope of impacts posed by many of the "grand challenges" faced by society.

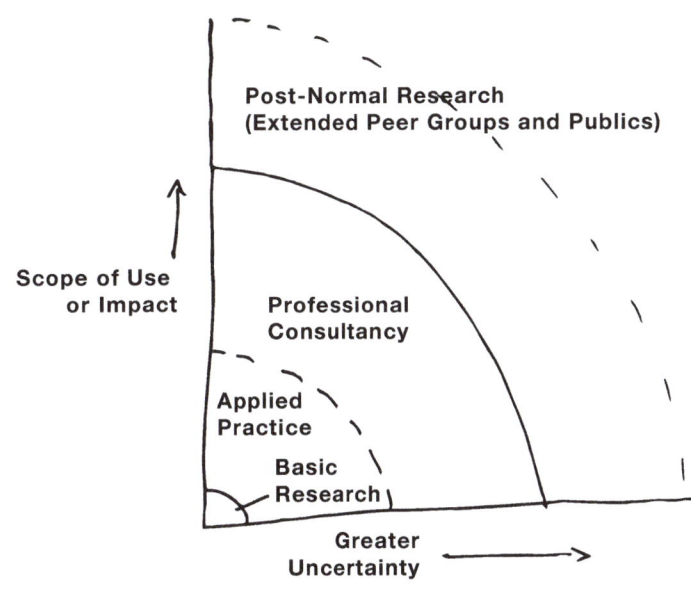

Funtowicz, S. O., & Ravetz, J. R. (1995). Science for the post normal age. In L. Westra & J. Lemons (Eds.), *Perspectives on ecological integrity* (pp. 146-161). Boston, MA: Kluwer Academic Publishers.

Iyengar, S. (2015, December 3). Taking note: Can/should we distinguish between basic and applied art? Art Works Blog, National Endowment for the Arts. Retrieved from https://www.arts.gov/art-works/2015/taking-note-canshould-we-distinguish-between-basic-applied-art

RESEARCH:
A Process That Means Different Things to Different People

DIVERSITY AND CONTEXT

> " I just think we don't always accept it in what would be normal in our discipline terminology. We tend to want to have to manipulate the discussion to fit it into terminology that's more appropriate for other disciplines. That's a long way of saying I think research involves what we would consider, I'm not going to go on to define it, but what we would consider standard venues of research, and I think it includes creative enterprises as well."

ASSOCIATE DEAN
MUSIC

> " There's a narrow definition of research, which I don't think is what you want, which is research is what the university says it is. Research is what is legible to a university as output. . . . I see research as a very context-specific framework."

ASSISTANT PROFESSOR
INTERDISCIPLINARY ARTS

Above: University of Arizona Center for Creative Photography intern Claire Perrott conducting a survey on photographic materials in the archives. Photo credit: Emily Una Weirich/CCP.

Research means different things to different people. In many respects, this may be the most important topic to emerge from the responses because it starts from the assumption that research is a cultural activity: it can be defined, constructed, and undertaken in many ways.

For one respondent, the approach to research "depends on what you are looking to support or find," or as another respondent remarked, "research is defined by the researcher – I don't believe there is a single funnel through which research can travel." Some respondents even said that their definition of research was explicitly left undefined in order to remain open to interpretation or to serve as a proxy for a variety of creative activities. In the writing disciplines, for example, this creative activity refers to writing and publishing. For one respondent, ". . . [research] is anything that has to do with what is or might become my artwork," and for another, "research is something that is done by a performer in performance spaces." Even for those working in the sciences, a great many revealed that while some shared foundations exist, the approaches that each person, lab, or department takes are substantially influenced by the paradigms, available technologies, and specific questions involved. For many, research is stipulative: research is what the researcher or researchers say it is.

"Oh well, I can wear two different hats to define that term."

"There's a narrow definition of research, which I don't think is what you want, which is research is what the university says it is. Research is what is legible to a university as output. That is a definition. There's also research, which is legible to the United States as output. The kind of research that I do, when I wear one of my hats, is legible to the university as research, it is not legible to the United States as research, because there are different standards. Considering I am a researcher and I produce research

output, then there is a contextual definition that within this space at the university it is research. How the university defines that is generally, what is not teaching, what is not service, and what is not an.... There's some outside jobs that wouldn't be.... That contributes to the university's mission of knowledge formation. I think what comes through my halting answers is that I see research as a very context-specific framework."

"How would I define 'research'? I explain to my graduate students when I'm teaching PhD students that research is the ongoing conversation among experts about important questions to our discipline and to our world. Research involves a process of listening to that conversation, getting a sense of what questions are being asked about a particular conversation, and then finding a way to intervene. Doing so moves the conversation forward, and hopefully that conversation leaks out from just our discipline and begins to affect other conversations and other disciplines even beyond the university."

"In the arts, we are a Research I university, and so there is enormous emphasis on research, and because we're highly dominated by the sciences and STEM disciplines, that definition tends to have a very traditional focus to it. We tend, in my opinion, to try to manipulate a lot of what we do to fit into that kind of terminology when I'm not exactly sure that it's the most appropriate and most accurate description, but we do what we need to do in the context where we are. In the arts, I think you could have research that falls under more traditional lines, particularly in areas, for example, like art history and musicology, those kinds of areas that fit standard definitions of what we think of as research. We have an awful lot of creative work, which in my opinion should be able to stand on its own. Yes, anybody who's involved in creative work does certain kinds of research in terms of if you're a pianist you're going to research the repertoire, you're going to research performance practices, and your product is going to be applying them into performance as opposed to putting them in a traditional paper and that's fine. I just think we don't always accept it in what would be normal in our discipline terminology. We tend to want to have to manipulate the discussion to fit it into terminology that's more appropriate for other disciplines. That's a long way of saying I think research involves what

we would consider, I'm not going to go on to define it, but what we would consider standard venues of research, and I think it includes creative enterprises as well."

"Well, I'll think about it in philosophical terms. That what philosophy does is look at the world and what is happening in it and – I'm not going to explain this very well, but critiquing it, holding it up against different lights and analyzing, looking at one situation in many different ways. It's a dialogue, back and forth, between the observer and the observed, critiquing back and forth, engagement. Research is a conversation between the person asking the questions and either the subject or the person answering the questions. Even if it is —or an art project, for instance, I think of that as a conversation as well. When I'm painting, that's a conversation between me and the canvas. So it's not just me coming at the canvas; it's me, the canvas, and the canvas speaking back, you know, and responding to the canvas. So there's this push and pull."

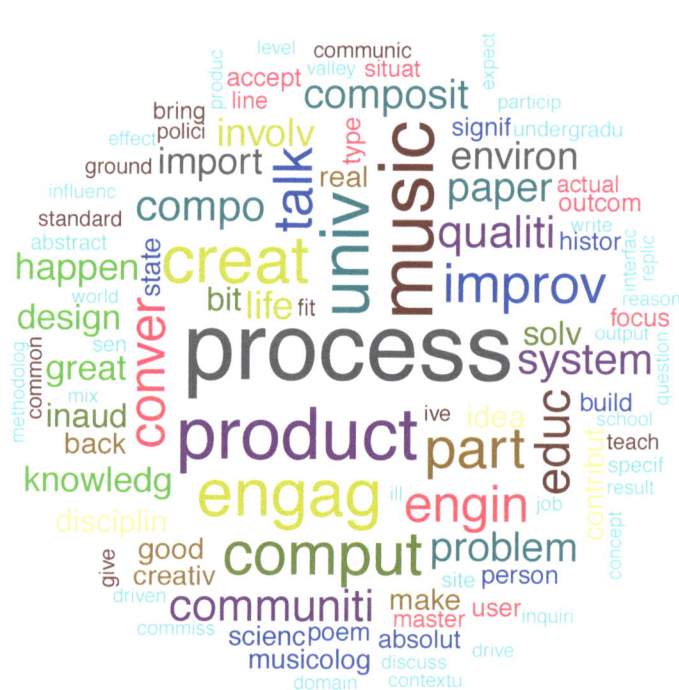

Above: A word cloud for the topic "A Process That Means Different Things to Different People" with words weighted by their probability. Larger words represent higher probability words for the topic, and color contrasts help distinguish probability levels.

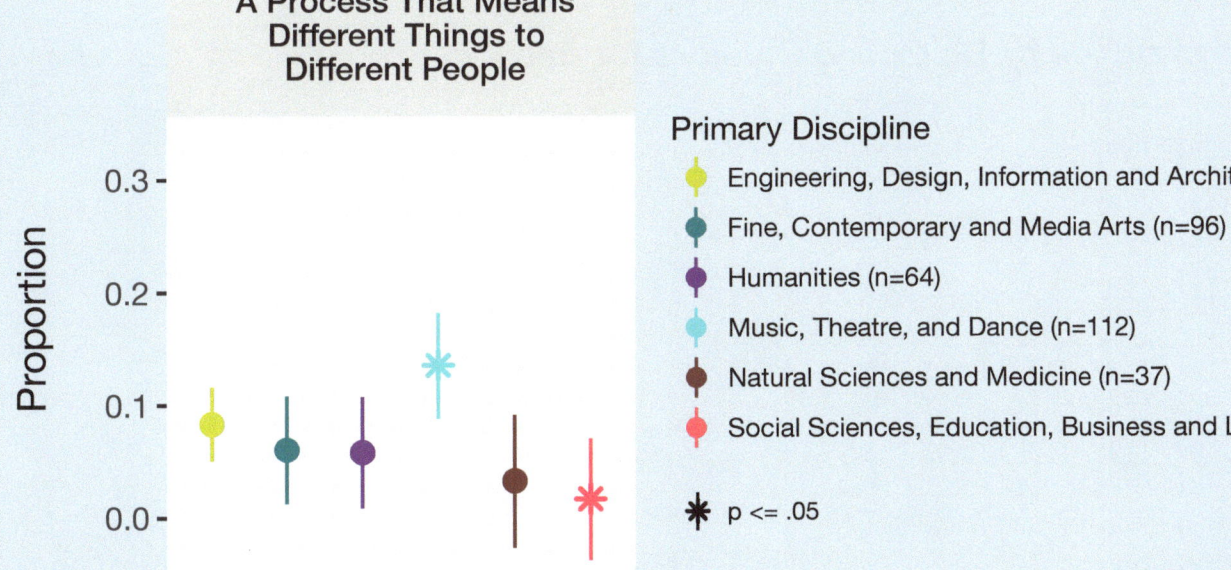

Above: Topic prevalence by discipline clusters for the topic "A Process that Means Different Things for Different People." Respondents whose self-reported primary disciplines included the Music, Theatre, and Dance cluster were more likely to identify or speak to the contextual nature of research in the university.

RESEARCH AS PACE LAYERS

The diagram above shows different types of research as pace layers. Pace layers change at different rates and work differently for different systems. The layers at the top are faster, trend toward innovation, and engage more directly with cognition and culture. The layers toward the bottom are slower, trend toward stasis, and engage most directly with infrastructure and institutions.

The "Pace Layers" framework comes from a diagram in Stewart Brand's book The Clock of the Long Now (1999). It appeared with the caption: "The order of civilization. The fast layers innovate; the slow layers stabilize. The whole combines learning with continuity." Its six layers were labeled in descending order from those that change quickly to those that change much more slowly: fashion, commerce, infrastructure, governance, culture, nature - much like shearing layers in a building (Brand, 1994). Since its initial publication, Pace Layering has served as a framework for thinking, designing, and managing systems and for the constructive friction that happens between layers.

Brand, S. (1994). *How buildings learn: What happens after they're built.* New York, NY: Penguin.

Brand, S. (1999). *The clock of the long now: Time and responsibility.* New York, NY: Basic Books.

INSIGHTS

Topic Prevalence by Discipline Clusters for Each Topic

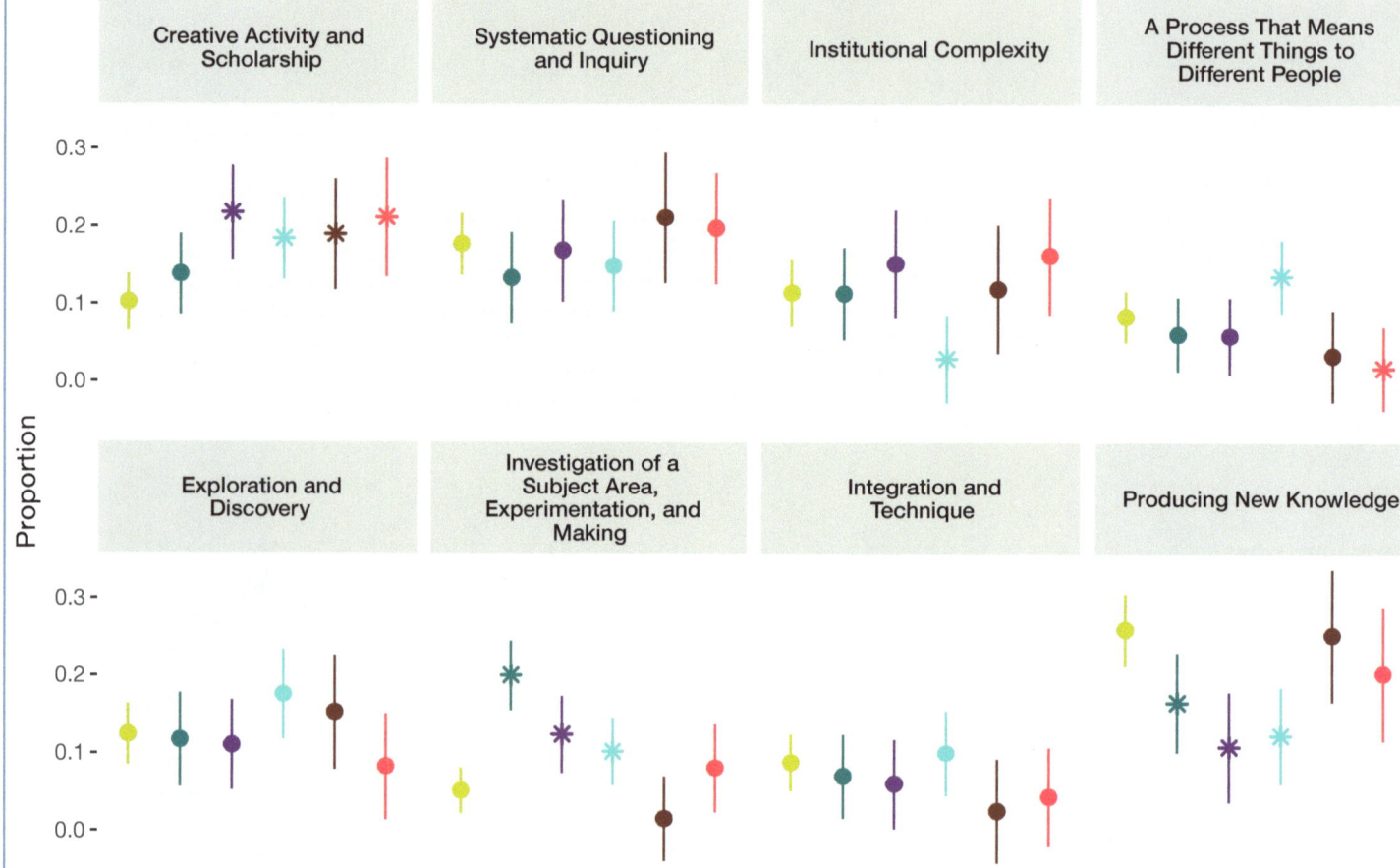

The figure above compares discipline clusters by the prevalence of each topic. Some topics, such as "Creative Activity and Scholarship" and "Investigation of a Subject Area, Experimentation, and Making" are present in relatively higher proportions for some discipline clusters such as the Humanities and Music, Theatre, and Dance. "Producing New Knowledge" is less prevalent among the Fine Arts, Humanities, and "Music" clusters. The topics "Systematic Questioning and Inquiry," "Exploration and Discovery," and "Integration and Technique" exhibit the fewest differences in topic prevalence.

Primary Discipline
- Engineering, Design, Information and Architecture (n=104)
- Fine, Contemporary and Media Arts (n=96)
- Humanities (n=64)
- Music, Theatre, and Dance (n=112)
- Natural Sciences and Medicine (n=37)
- Social Sciences, Education, Business and Law (n=44)

Significant Difference?
- ● Not Sig.
- ✱ $p \le .05$

INSIGHTS

Topic Prevalence by Topic for Each Discipline Cluster

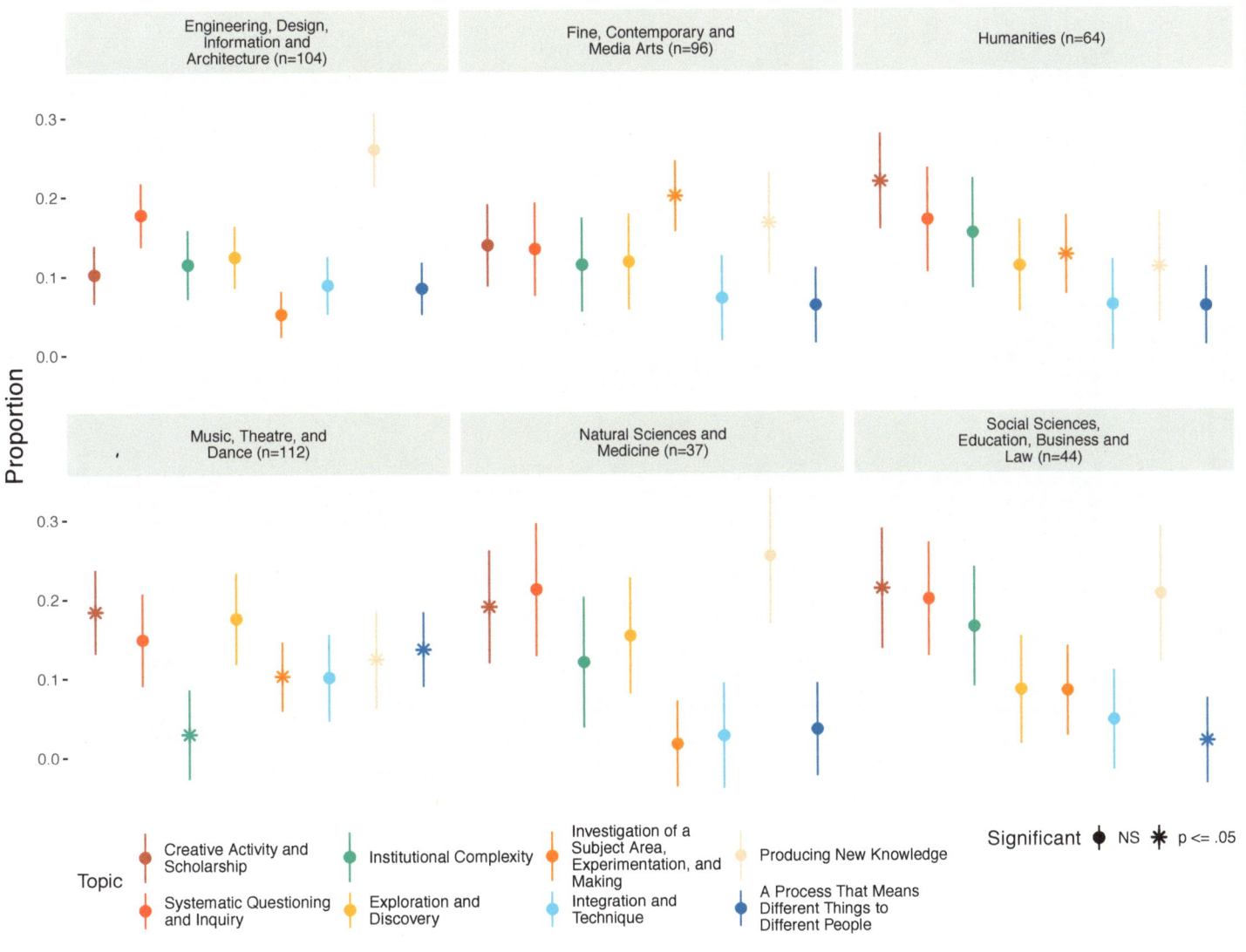

The figure above uses the same results as the figure on page 35, but topic comparisons are organized by disciplinary clusters instead. Significant differences refer to topics, so while the Natural Sciences and Medicine disciplinary cluster exhibits a somewhat lower prevalence of the topics "Investigation and Making," "Integration and Technique," and "A Process That Means Different Things to Different People" when compared to other topics, their prevalence is not significantly different when compared to other disciplines.

INSIGHTS

Topic Prevalence by Presence of Doctorate Degree for Each Topic

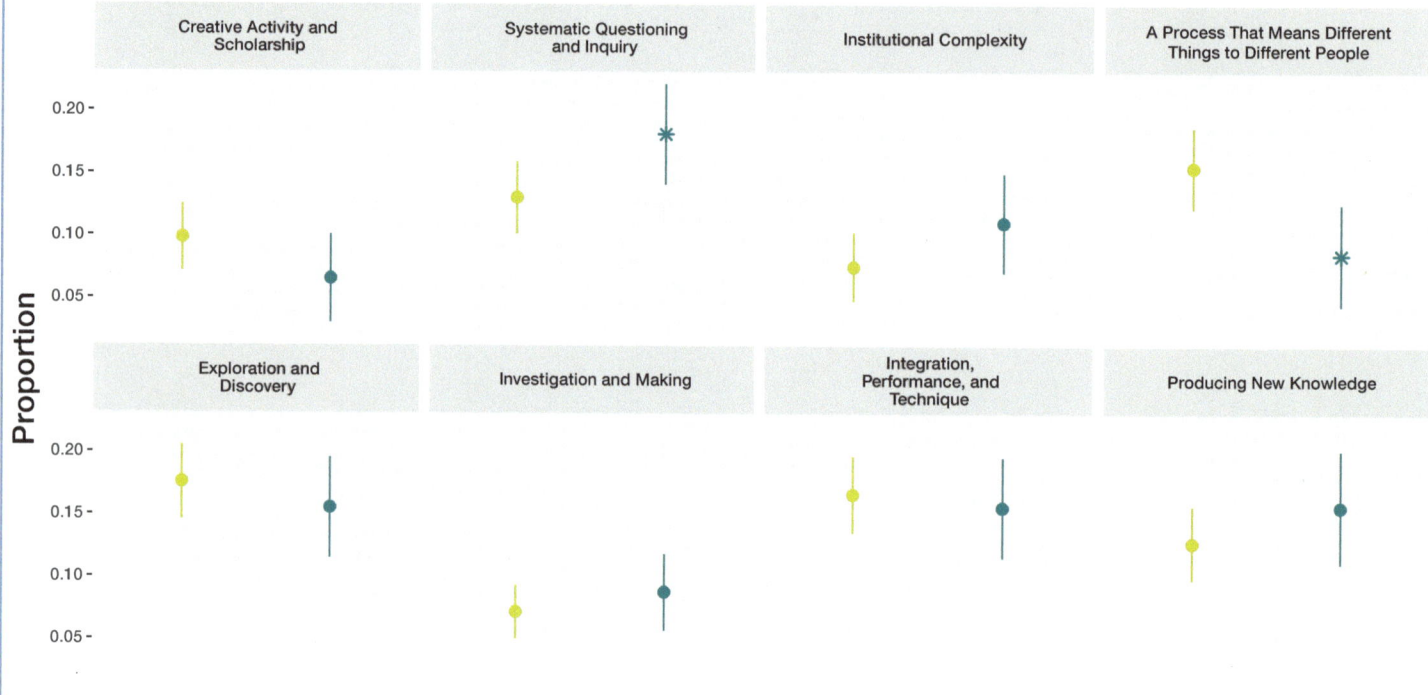

A Greater Prevalence of Research as "Systematic Questioning and Inquiry" Among PhDs: The figures above show comparisons of the topic prevalence among responses when using "PhD/no PhD" as a variable. Respondents who indicated that their highest degree level included a PhD were more likely to suggest that research involves "Systematic Questioning and Inquiry" and relatively less likely to say that it is "A Process That Means Different Things to Different People." Overall, the variation in topic prevalence was explained better by the discipline cluster variable than it was by having a PhD.

METHODS

Data Analysis

Interviews were recorded on video, and beginning in 2016, they were transcribed to text by a transcription service, cleaned of information that would directly identify interviewees, assembled into discrete question-and-response pairs, and parsed onto data sheets with metadata about their institutions. The resulting dataset represents the responses of 472 individual interviewees and over 8,652 unique question-and-response pairs. Full-text interviews and data sheets are archived at the National Archive of Data on Arts and Culture (NADAC) with support from the National Endowment for the Arts.

Responses to the question *"What Is Your Definition of Research?"* were drawn from 38 institutions of higher education, most of which are research universities. We asked interviewees to define what research means to them as one question of a semi-structured in-person interview (Mackh, 2015). In order to make summary comparisons, additional metadata variables were created in OpenRefine to group respondents by discipline-based clusters that share some cultural similarities (pp. 35-36 of this brief). Topic prevalence was also estimated for respondents based on whether they held a PhD as their highest degree or not (p. 37 of this brief). Using 457 full-text responses as data, we employed a probabilistic topic modeling approach (Roberts et al., 2014, 2017) to provide machine-assisted reading and categorization of the interview response texts.

The table below shows the total number of individual responses for each disciplinary cluster used as a factor level in the analysis.

Discipline Cluster	n respondents
Engineering, Design, Information, and Architecture	104
Fine, Contemporary, and Media Arts	96
Humanities	64
Music, Theatre, and Dance	112
Natural Sciences and Medicine	37
Social Sciences, Education, Business, and Law	44

Interpretation Notes and Discussion

In general, the respondents tend to view research as a mixture of objectives, activities, and practices. Heteroglossia is the co-occurrence of perspectives, ideas, or modes of expression within a single text (Bakhtin, 1982; DiMaggio, 2013), and it is common among these interview responses. Even highly prevalent definitions and modes of research are contingent, framed, and shaped by multiple ways of questioning, working, and knowing. This suggests that many researchers' influences and practices are more flexible to coordination than they may sometimes appear. Good communication and collaborative practice may then be more of a question about "when" different modes of research unfold or for what purpose.

METHODS

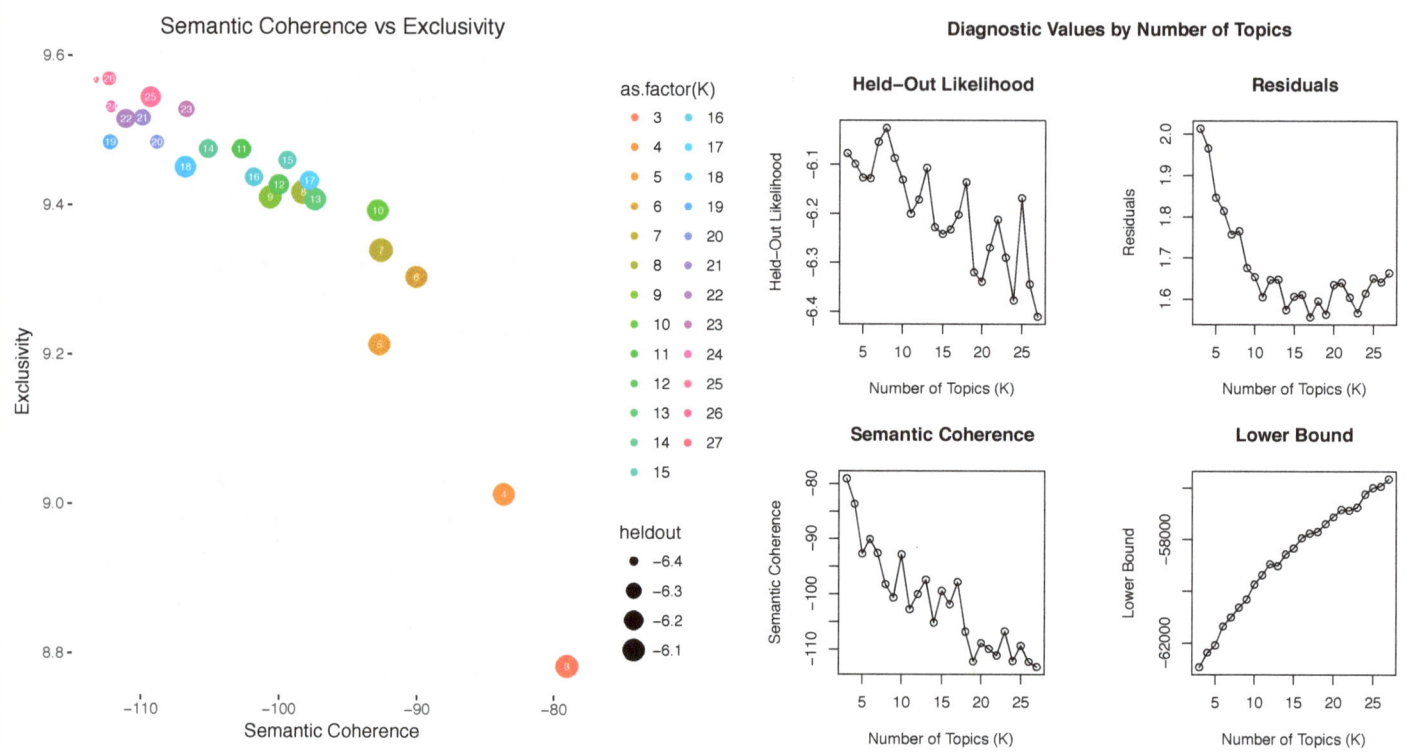

Diagnostic Information for Selecting Topic Number and Model Fit

The figures above show a series of plots with diagnostic information used to help select the number of topics that provide the best model fit for data. In selecting a model to fit the data, a range of models was explored to find one that provided the best fit while also balancing trade-offs between the semantic coherence of each topic and the level of exclusivity that distinguishes each topic (top left; Roberts et al., 2014, 2018). In general, models with higher held-out likelihood suggest a better fit with the data, while the complementary estimates of semantic coherence and exclusivity provide insight into the quality of the model. It was also important to incorporate a close reading of the interview texts to select an appropriate number of topics for the model. Using insights into the culture of research universities and the domains being studied, a model with eight topics was selected.

METHODS

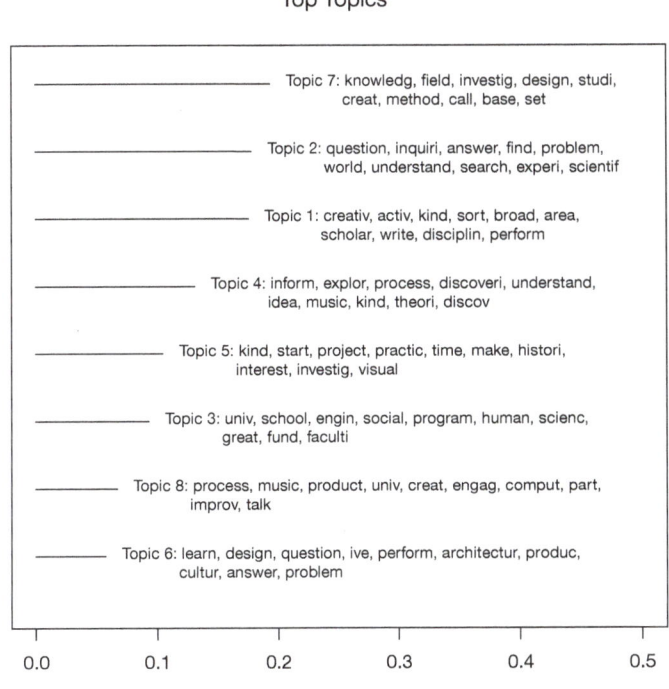
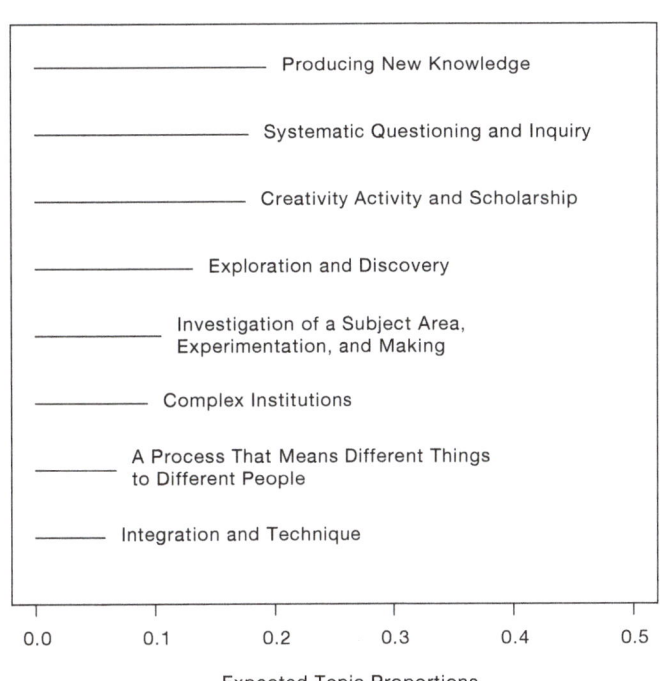

Interpreting the Topics

Each of the candidate topics was verified, labeled, interpreted, and described using high probability terms provided by the model and the full texts from the top 21 interview responses for each topic. High probability terms for each of the eight topics and their expected topic proportions are shown here (upper left) as a distribution across the entire corpus of responses. Topic labels and descriptions were written to provide detail and clarity for each topic (upper right). The topics that emerged for the question *"What Is Your Definition of Research?"* are what one might expect, but they also provide some surprises. "A Process That Means Different Things to Different People" and "Institutional Complexity" are meta-topics whose labels came from interpreting the context and diversity of responses, rather than the word content alone.

METHODS

While there are multiple differences in the prevalence of certain topics for different disciplinary clusters, this does not mean that all topics are totally absent. Instead, it suggests that a more probabilistic outlook is warranted, where assumptions about disciplinary identities and practices can be weighted by these observations, but also suggests that they are ultimately best served through ongoing integration of research goals, context, personalities, experiences, and opportunities.

Multiple factors may affect the topic identities and patterns described here in ways that would shift these results from population to population. Cognitive factors such as the level of expertise and experience of the individuals sampled may result in a somewhat more or less nested hierarchical branching pattern as shown in the tree diagram on pages 2-3 of this brief, as well as differences in topic coherence. The relative proportion of each topic in the topic distribution may also change from group to group as a function of population drift and group identity. And finally, the domain experience and judgment of those evaluating and reading the texts in order to provide topic names are likely to influence the interpretive process leading to the identity of each topic.

Despite these factors, it's reasonable to expect that the overall shape and identity of the topics would remain relatively stable from group to group, provided a large enough sample.

Future work could investigate additional levels of description and practice for each of the topics described here. A first approximation would be to assemble brief literature reviews for each of the eight topic areas, followed by interpretation of how specific disciplines map their practices to each topic area. This kind of approach could prove especially useful in surfacing examples for comparison, shaping language and communication, and fostering critical reflection and judgment about interdisciplinary modes of research and practice.

References

Bakhtin, M. M. (1982). *The dialogic imagination: Four essays.* (M. Holquist & C. Emerson, Trans.). Austin, TX: University of Texas Press.

DiMaggio, P., Nag, M., & Blei, D. (2013). Exploiting affinities between topic modeling and the sociological perspective on culture: Application to newspaper coverage of U.S. government arts funding. *Poetics,* 41(6), 570-606.

Mackh, B. M.. (2015). *Surveying the landscape: Arts integration at research universities.* Ann Arbor, MI: ArtsEngine, University of Michigan.

Roberts, M. E., Stewart, B. M., Tingley, D., Lucas, C., Leder-Luis, J., Gadarian, S. K., . . . Rand, D. G. (2014). Structural topic models for open-ended survey responses. *American Journal of Political Science.* 58(4), 1064-1082.

Roberts, M., Stewart, B., & Tingley, D. (2018). stm: An R package for Structural Topic Models. [http://www.structuraltopicmodel.com]

FOLLOW-UP: QUESTIONS AND TASKS FOR BUILDING UNDERSTANDING

For each category of research, try to identify three examples from your institution.

For each category of research, try to identify and compare three different examples from somewhere else.

For each category of research, what are the shared methods and/or practices that are common to your examples?

What kinds of things does each type of research do to establish it credibility, trustworthiness, and impact on others? How are these communicated?

What instructional, teaching, and/or learning activities would be relevant for deepening understanding and expertise in the category?

What kinds of institutional barriers might get in the way of each type of research activity?

What kinds of incentives or programs could encourage ongoing integration among different forms of research?

Compare and contrast each type of research. What communications challenges might potential collaborators face when encountering others who have a different view? How might collaborators clarify, negotiate, or resolve their differences?

FOLLOW-UP: QUESTIONS AND TASKS FOR INTEGRATION AND PRACTICE

Applying the results of this research to practice can unfold in many ways. Some of the easiest applications involve using the categories for program development and criteria as well as domain areas for teaching and learning. The categories described in these pages are prototypical, and they will continue to be refined and developed as new examples and nuance to our understanding are added.

Apply and integrate the categories to design and develop:

- a conference or symposium
- a course sequence or syllabus
- collaborative, team-based projects
- criteria for requests for proposals (RFPs) or grantmaking criteria
- seeds for discussion of criteria for reappointment, promotion, or tenure
- individual class or studio-based assignments and activities
- facilitated sensemaking sessions for your group, department, or college
- messaging and language for communications to different audiences
- case-making and advocacy materials for building awareness
- timelines or evaluation strategies for research projects
- a map of existing research activities
- research strategy for your institution
- improved research foundations training modules

www.ingramcontent.com/pod-product-compliance
Lightning Source LLC
Chambersburg PA
CBHW041320180526
45172CB00004B/1171